PUPPIES BEHIND BARS
TRAINING PUPPIES TO CHANGE LIVES
PHOTOGRAPHS

PUPPIES BEHIND BARS

TRAINING PUPPIES TO CHANGE LIVES

PHOTOGRAPHS

CHRISTOPHER MAKOS | PAUL SOLBERG

Glitterati
INCORPORATED

NEW YORK, NEW YORK

First published in the United States of America in 2007 by
Glitterati Incorporated
225 Central Park West
New York, New York 10024
www.GlitteratiIncorporated.com

Copyright © 2007 Puppies Behind Bars, Inc.
Photographs copyright © 2007 Christopher Makos and Paul Solberg
www.puppiesbehindbars.com
www.makostudio.com
www.paulsolberg.com

Puppies
Behind
Bars

Puppies Behind Bars is a registered trademark of Puppies Behind Bars, Inc. and cannot be used without permission.

First edition, 2007

Design by Kathy McGilvery
www.mcgilverydesign.com
Library of Congress Cataloging-in-Publication data is available from the Publisher

Hardcover ISBN 0-9765851-5-4
 ISBN 13: 978-0-9765851-5-2
Boxed edition ISBN 978-0-9765851-6-9

Printed and bound in China by Hong Kong Graphics & Printing Ltd.
10 9 8 7 6 5 4 3 2 1

CONTENTS

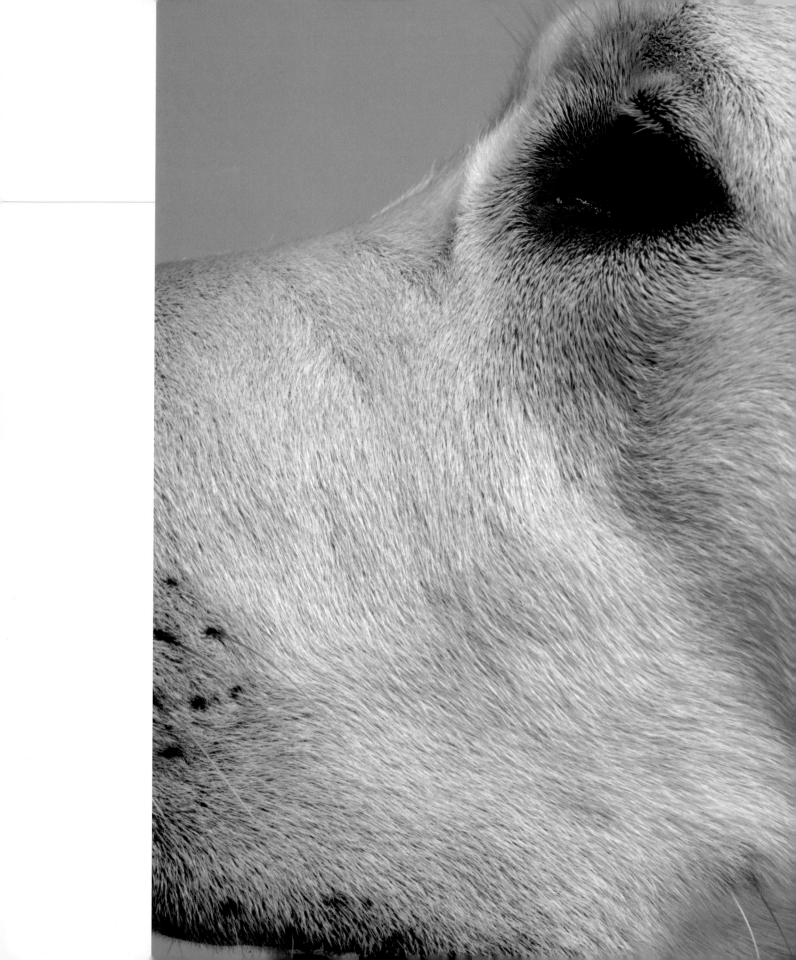

PREFACE

On Wednesday, April 26, 2006, on Continental Airlines flight 49 to Houston, I was on my way to contribute photographs to a nonprofit organization that was sponsored by Baylor College when I found myself making a friend with a beautiful Labrador retriever. The Boeing 767 was all abuzz with curiosity as to why there was a dog sitting in a first-class seat on his way to Texas. I wondered why this dog was allowed the privilege of riding in the cabin section of the plane, rather than the usual "below deck" that is usually reserved for the animal kingdom. Since the dog had boarded late, there was no time for any explanation, but I did notice how friendly he was, and how comfortable the presence of this canine beauty made everyone feel.

Right after the meal service this beauty started to roam around the cabin and introduce himself to the passengers. As it turns out, this dog was no usual dog; this dog was just finishing up his acclimation training to enable him to handle diverse social situations, including that of airplane flights. He was a Puppies Behind Bars graduate, being literally "air lifted" to a final destination home in Houston, Texas.

How lucky were we all to have this well-behaved, loving creature on our flight—he was our St. Francis of Assisi guardian dog. When it became my turn to meet "Chauncey," it was then I heard the story of his training by prison inmates—and basically the 411 on why the dog was on the plane. I thought a star like this shouldn't be just momentarily appreciated, but needed to be memorialized in photographs. After all, I was on my way to

work with one nonprofit; how amazing it was to be meeting a member of another charitable organization who seemed ready to be photographed along the way. What ensued were some pretty amazing images. The last photograph in this book is the farewell shot from flight 49.

After that flight, I began emailing back and forth with Gloria Gilbert Stoga, the founder and president of Puppies Behind Bars, to show her what I had captured on the flight. What evolved from that point is this book. Knowing that this was too big of a project for one photographer to tackle alone, I teamed up with Paul Solberg, whose sensibility in photography is a perfect counterpoint to my own.

Through this project we have brought to light a multifaceted "take" on dogs, one that has not been seen in photographs prior to this book. That just might be because the dogs from the Puppies Behind Bars program are unlike any that have been photographed before: They are so attached to humans, to our eyes and thus to our camera, that the photographs of these expressive dogs connect with every human being who views them—whether in person or through the lens of our cameras. What has emerged is a book full of images that tell the story of love.

Christopher Makos
New York City

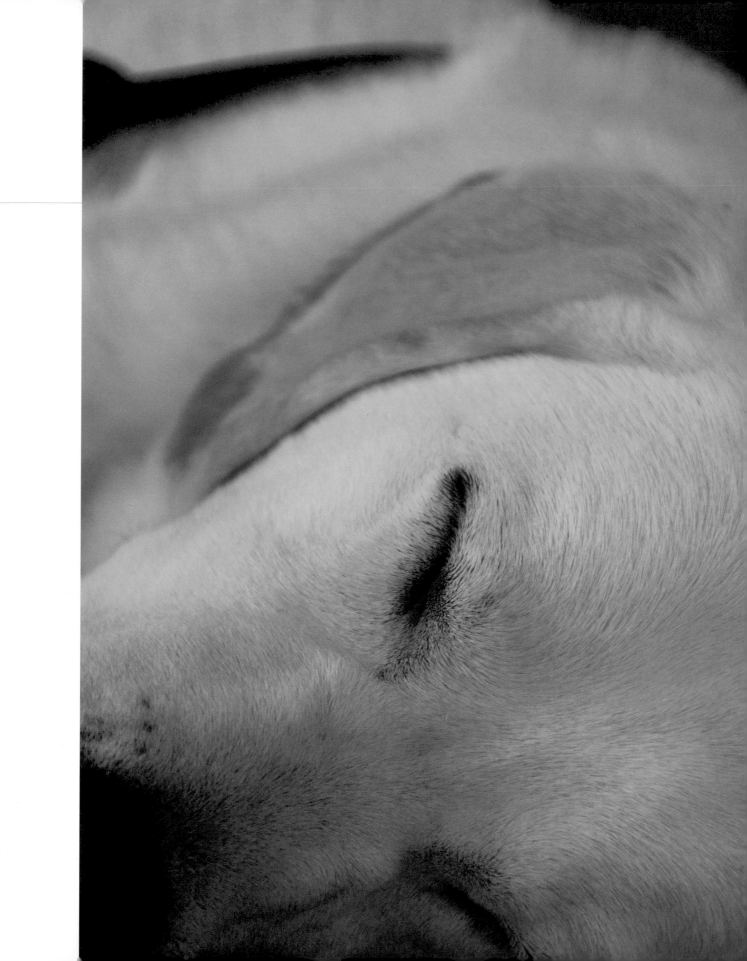

F O R E W O R D

I'm allergic to dogs. So, in the past, the relationship could only go so far.

When Chris called me from the airport to tell me about the unusual sighting of the dog in first class, his enthusiasm was infectious, as it often is. To my surprise, Chris asked me to join him, if this materialized into some kind of project. Three months later, I packed up my allergy pills, and we were off to prison.

It was the perfect weather for the quintessential first prison experience. Grey clouds, grey light. Cold. Damp. Walking up the hill to what seemed like miles of barbed wire. After predictably exhaustive security, we were escorted through several doors, with locks that rattled your knees. A reminder of where you were.

With this first impression, I only expected the experience to continue with this dark and ominous treble.

It was not what I had expected.

"The Human Condition" can parallel "The Dog Condition." There are givers and there are takers; under-achievers and over-achievers; and there are dreamers. Some have the fortune of higher education, while some have what it takes, but can't seem to catch a break. The dogs I photographed are the gifted handful who have it all, and have worked hard for it; and still, after all the success, their only interest is to give to others.

But like most pillars of society, they don't make it to the top alone. As we know, it takes more than being simply gifted to succeed. The luck of having a brilliant teacher, who forgets teaching is a job and who invests in another with abandoned passion; this changes people. It also changes dogs.

For the dogs that I photographed, the inmate seems the dream teacher. The education is constant. When there are breaks from learning, it's about playing, jumping, hugging, kissing; a recipe to make anyone a superhero. After eighteen months, the once untrained dog can turn on lights for the handicapped and detect explosives to protect our cities.

Maybe my cynicism makes me hesitant to use the mistreated word, Love, but it would be inauthentic to avoid it. Dogs can be healers. Love doctors. They can't mend the past, but they can remind us of hope. The dogs' gift is blind love, and in exchange, all they want is our time, something inmates have in abundance.

Unconditional love changes all of us, and manifests itself in finding purpose, self-respect, and a connection to others. Perhaps this is the most potent force to reform us all.

Paul Solberg
New York City

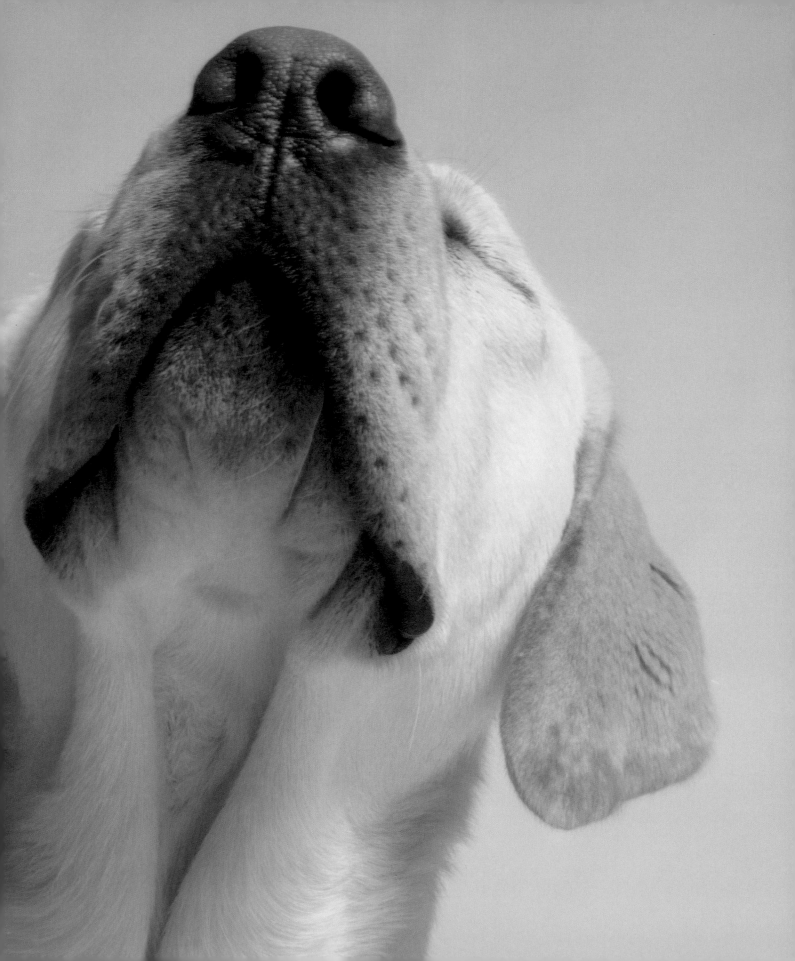

The story of Puppies Behind Bars begins with a refrigerator.

Sixteen years ago, I was shopping with my husband in an appliance store for a new refrigerator, or rather, he was looking at refrigerators while I was trying to persuade him that no family could be complete without a dog. Although he had grown up with and loved dogs, he was skeptical that two employed people with two growing children needed the added demands of raising a puppy in their already full lives. Bored with talking about top or bottom loading freezers, BTUs, and icemakers, I explained again why a dog would be an important addition to our family.

My husband had long since tuned me out, but a few minutes later, a salesman pulled me aside and said, "I couldn't help but overhear your conversation about dogs. If you ever want to get one, you should do what we did: Adopt a retired dog from a guide dog school. Ours is a trained, wonderful dog. It is the best decision we ever made."

I thanked the salesman; we bought a refrigerator, and went home. Soon months passed with no progress on the dog front. Then one day, I suddenly recalled the conversation at the appliance store and decided to take the matter into my own hands. I would find a guide dog school and I would find us a perfect dog. In doing so, my husband's fears about training and caring for a puppy would be allayed, and we would have a new member of the family.

In those pre-Google days my search for a guide dog school was taking longer than I wanted, so I called the appliance store with what I am sure was an unusual request: Did they know how to find a good guide dog school so we could adopt a dog? The man who answered replied, "Lady, this is an appliance store, not an animal shelter!" and promptly hung up.

I called back. Before he could hang up a second time, I pleaded my case: I had been working on my husband for months about getting a dog and one of the salesmen in the store told me how to get a perfect dog and if I could only find the source of this perfect dog, I was sure my husband would let me get him so could you please not hang up on me and just ask all the employees who was the one with a retired guide dog?

As eloquent as I thought my plea was, the salesman hung up again. It took me months to find the organization Guiding Eyes for the Blind, but when I finally did, I submitted our application. A year later, my family and I adopted "Arrow," an 18-month old black Labrador retriever who was being released for medical reasons.

Arrow quickly became an integral part of our family and I began reading about the breeding, raising, and training of guide dogs. I also began noticing them work on the streets of Manhattan: How they maneuvered busy sidewalks, how they led their owners through intersections, how they handled riding the subway with complete confidence. While my family and I loved Arrow beyond words, part of me always felt guilty that he was our pet and not working for someone who needed him even more than did we.

A few years later my sister gave me a magazine article about inmates at an Ohio prison who were raising potential guide dogs. The article was very short, but what caught my attention was a photo of an inmate sitting in the grassy prison yard with a gorgeous yellow Lab in front of him doing a high five—the big man's hand touching the yellow Lab's paw. That photo said more to me about love, dependency, hope, and joy than anything I could remember. Every six months or so I

would pull that article out of my drawer, cry a bit, and think about how much sense the whole thing made.

Time passed. One day I unfolded the article yet again. This time my husband said to me, "Gloria, stop talking about it. Either do something or forget about it." He is not always right, but he was this time. I either had to quit my job and take all the risks involved with building something from scratch, or get on with life as it was.

So I took the plunge and after seven months, Puppies Behind Bars (PBB) was born. From the start I knew that I wanted to work with inmates as well as with dogs which, properly raised and trained, could make an important contribution to society. I knew that I wanted to build a program that would be characterized by the highest possible degree of professionalism and discipline, that would impart valuable skills to inmates, and that would produce high-quality working dogs. And I knew I wanted to build a program that, above all, could be trusted and respected—by the administrators who run the prisons in which we would work, by the people who would receive our dogs, by the breeders who would supply our dogs, by the supporters who would fund us, and by the inmates who would do the intense work of raising our puppies. Unfortunately, I also knew next to nothing about prisons and inmates, about dogs (beyond what every dedicated pet lover knows), or about working with the professionals who devote their lives to corrections, raising dogs, or training working dogs. The learning curve was steep from the very first moments—and I have not stopped learning since.

PBB has come a long way. We've trained and worked with hundreds of inmates in New York, New Jersey, and Connecticut; we've raised more than 400 puppies and we've developed a broad network of relationships in corrections, the

dog world, among the blind and physically disabled, and the organizations that advocate on their behalf. We've built a community of funders, volunteers, professional staff, and friends who care about this organization as much as do I. Along the way our mission has evolved: After 9/11 we began raising explosive detection canines as well as guide and service dogs. Most importantly, we have built a reputation based on professionalism, discipline, and trust and one of the keys to that reputation is how we work with inmates.

When I launched PBB, I knew that our puppy raisers would be better at what they did if they understood the "why" as well as the "how." We challenge inmates to learn and to achieve; our curriculum includes regular homework, graded quizzes, and assigned reading as well as guest speakers who supplement our PBB instructors. We also challenge inmates by setting high expectations for puppy raising skills and knowl-

edge levels, and insisting that individuals take full responsibility for the dogs under their care. Of course, that means that some raisers drop out or are dropped, but that makes those who remain even prouder of what they accomplish.

When I speak to groups about PBB, I am inevitably asked two questions: What is it like for inmates to give up dogs they've raised from eight-week-old puppies? And, how has this experience changed me?

The answer to the first question is easy. PBB inmate puppy raisers feel incredibly sad when they say goodbye to their dogs. They inevitably cry—men as well as women—and they often go to their cells to be alone in their sorrow. However, they also feel very proud of what their dogs are about to do.

The dogs are going out in the world to help someone who is blind lead a richer life. They are going to partner, hand in paw, with law enforcement agents to find explosives before they claim

innocent victims. They are going to turn on and off lights, carry grocery bags, and pick up a remote control for a disabled person in a wheelchair. And, through our program of donating some of our dogs that do not become working dogs to families with blind and disabled children, they are going to help a child enjoy a dog's tenderness and love that can change their lives.

The inmates are also very, very proud of themselves for having succeeded in a project when most people expected them to fail. Against the odds, they have undertaken a serious responsibility and stuck with it, sometimes for the first time in their lives. They have done everything they possibly could for almost two years to help a puppy grow into a successful, well-mannered working dog. Sure, they had fun with them when they were young pups, but they also got up in the middle of cold winter nights when their puppies needed them; spent hours in classes learning proper dog raising, care, and grooming techniques; and passed many hours training their pups. Above all, they learned what it was to love again, to trust again, and in the words of one of our inmates, "to be a human being again."

The answer to the second question—how PBB has changed me—is more complex. I have learned more than I ever imagined about dogs, about prisons, about the challenges of being disabled, and countless other subjects. I had expected that. What I did not expect was that working in a corrections environment would lead me to reassess my feelings toward inmates, toward the criminal justice system, and toward the entire notion of remorse, forgiveness, and second chances. Just as PBB has changed the lives of many inmates and recipients of our dogs, it has also changed mine.

In the pages that follow, you will see photos of some of our inmates and their dogs. You will see some of our volunteers, who selflessly give their time and their families' time to help socialize our dogs to the sounds and sights of suburban malls and soccer games, to the chaos and crowds of New York City, and to countless other experiences that make them more valuable to their eventual working partners.

In these pages you will meet Gussie, a 99-year-old volunteer with PBB. Gussie is part of our Paws & Reflect program, started in 2005. Every weekend, some of our dogs go into the apartments of homebound elderly in New York City. There they are exposed to walkers and oxygen machines, and learn how to modulate their energy level when they are around people who are frail. Paws & Reflect makes 350 visits each year. We are not paying social visits to the elderly, but asking them to help us raise future working dogs.

And, to round out the picture of who we are and what we do, you will see photos of Jake and Rafael, who served time in prison, joined Puppies Behind Bars there, and today put what they learned to work every day as members of our professional staff.

You will also read a few anecdotes from the past decade, which I think is the best way to tell the story of PBB. I hope this will give you a sense of the impact our dogs have on people, including law-abiding citizens and convicted felons, the sighted and the blind, the able and the disabled, the criminals and the cops. Perhaps you will begin to look beyond the differences among people and see the similarities, which is really what PBB is all about.

Gloria Gilbert Stoga
New York City

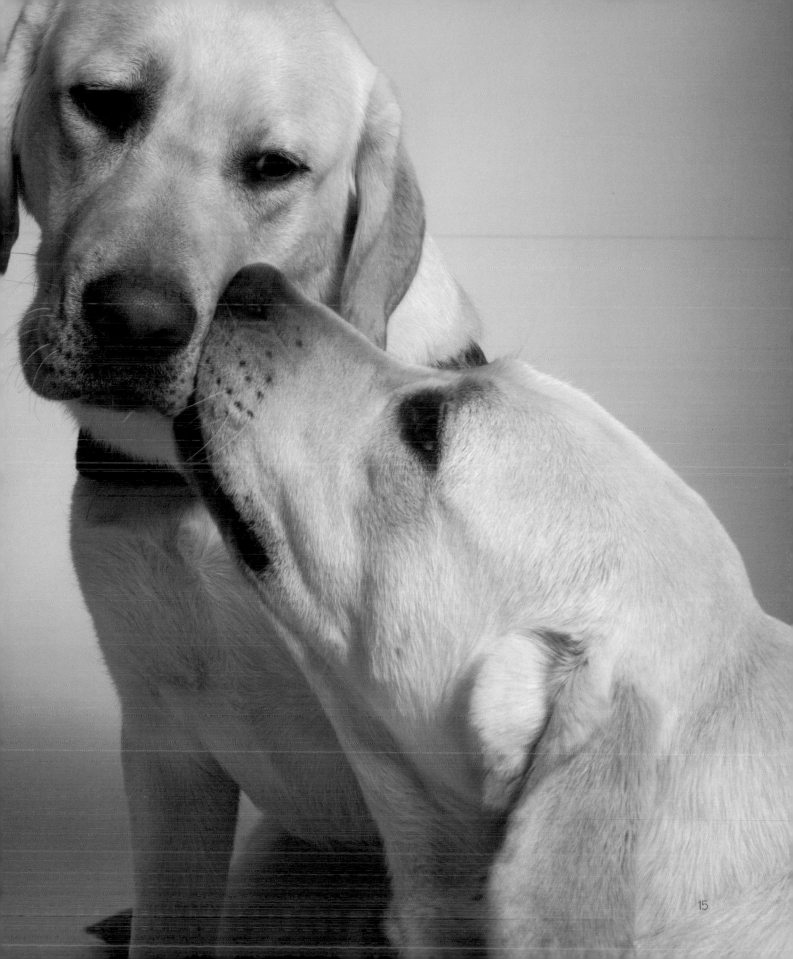

"Something nobody knows about me is: I'm full of love."

Michael, Mid-Orange Correctional Facility

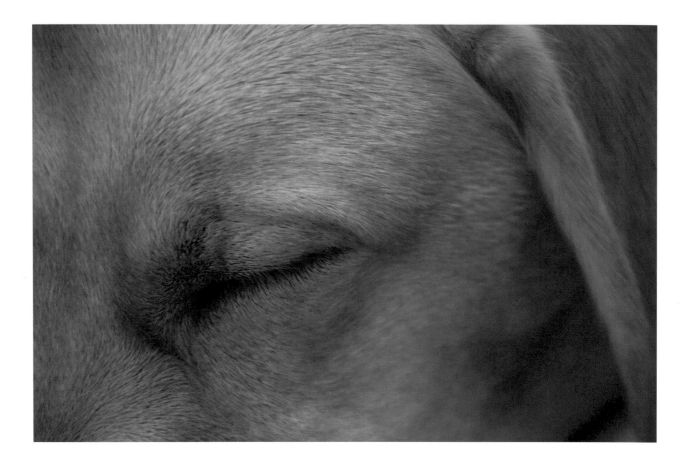

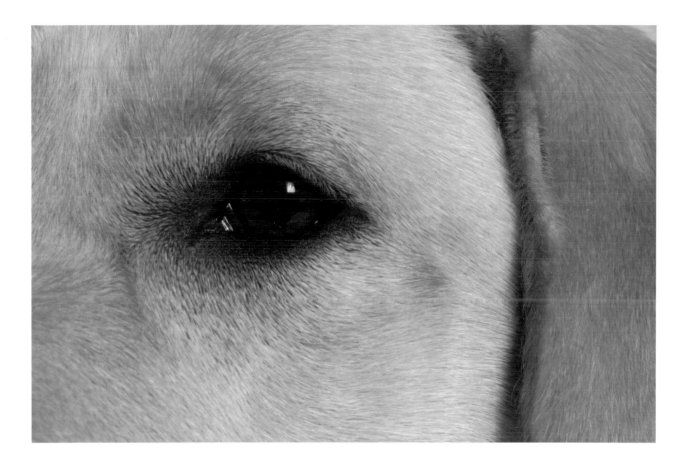

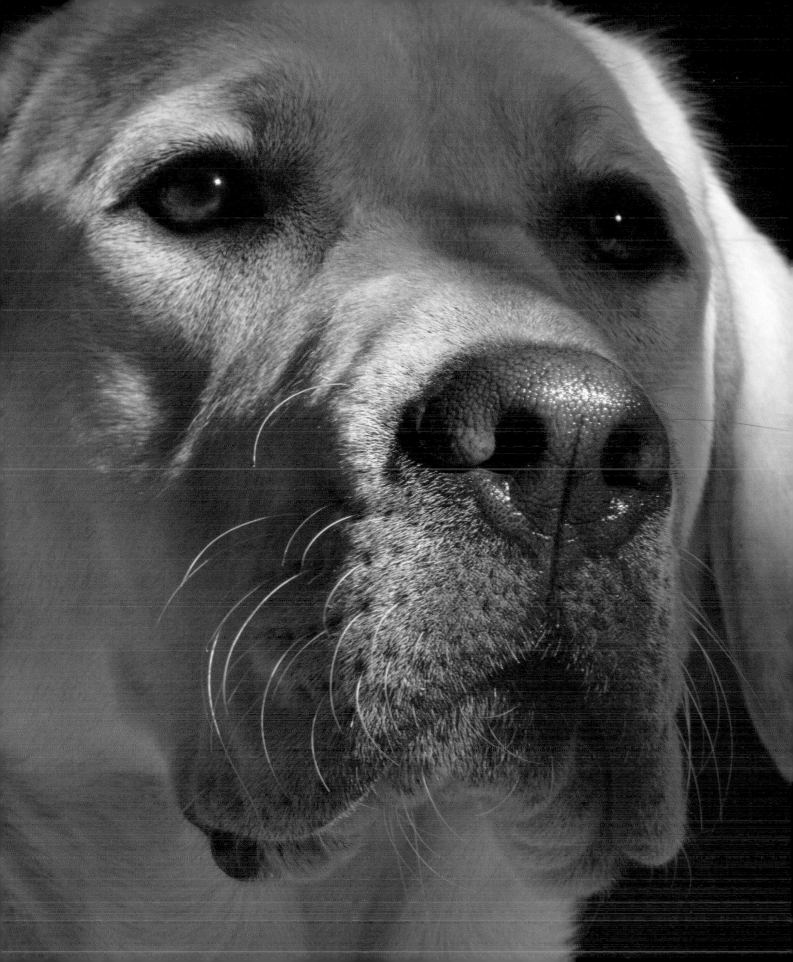

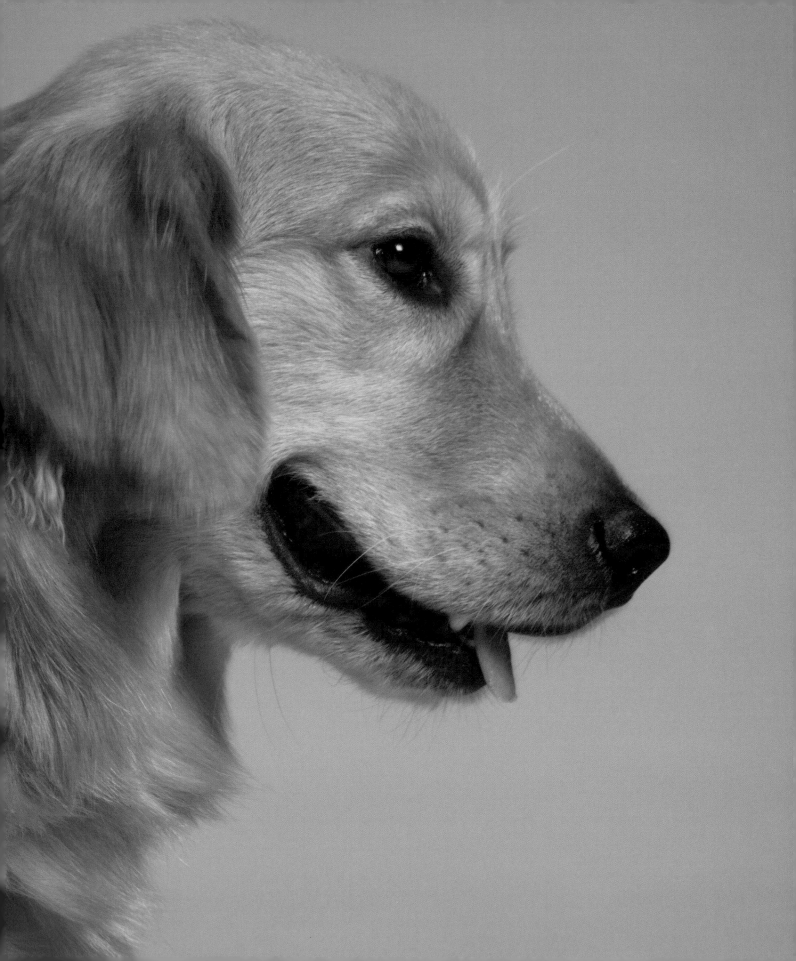

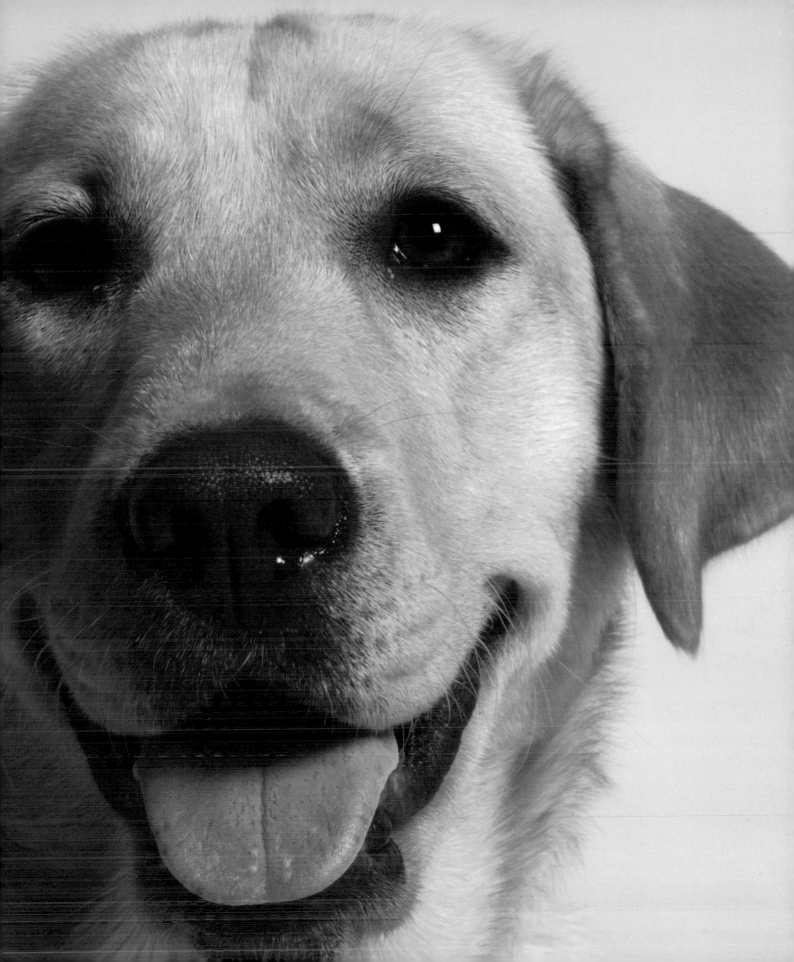

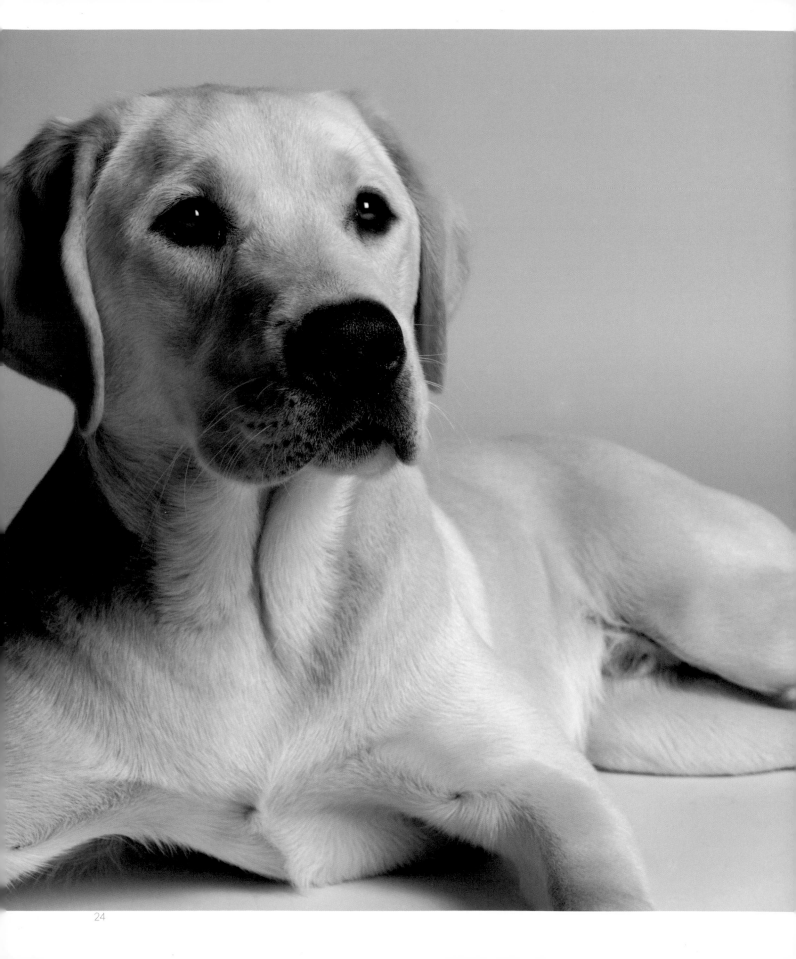

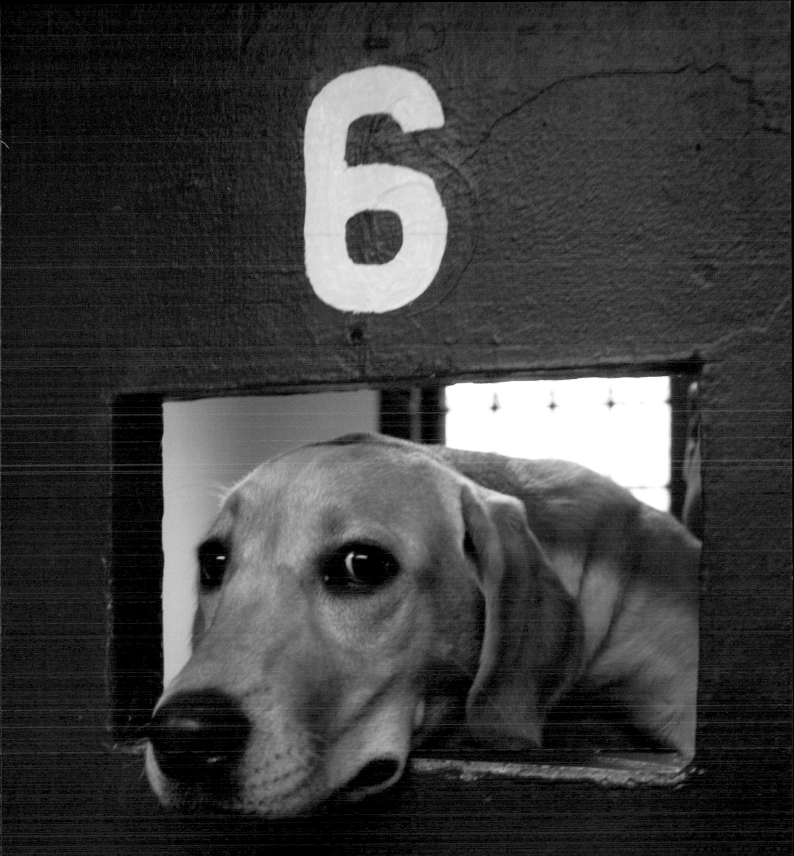

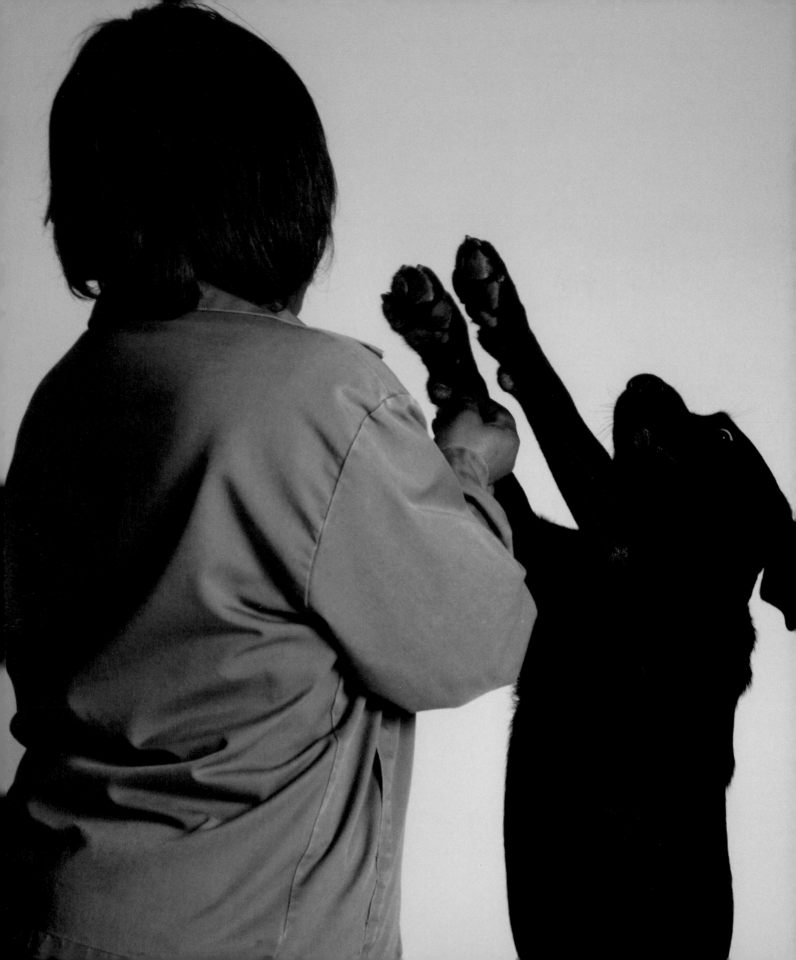

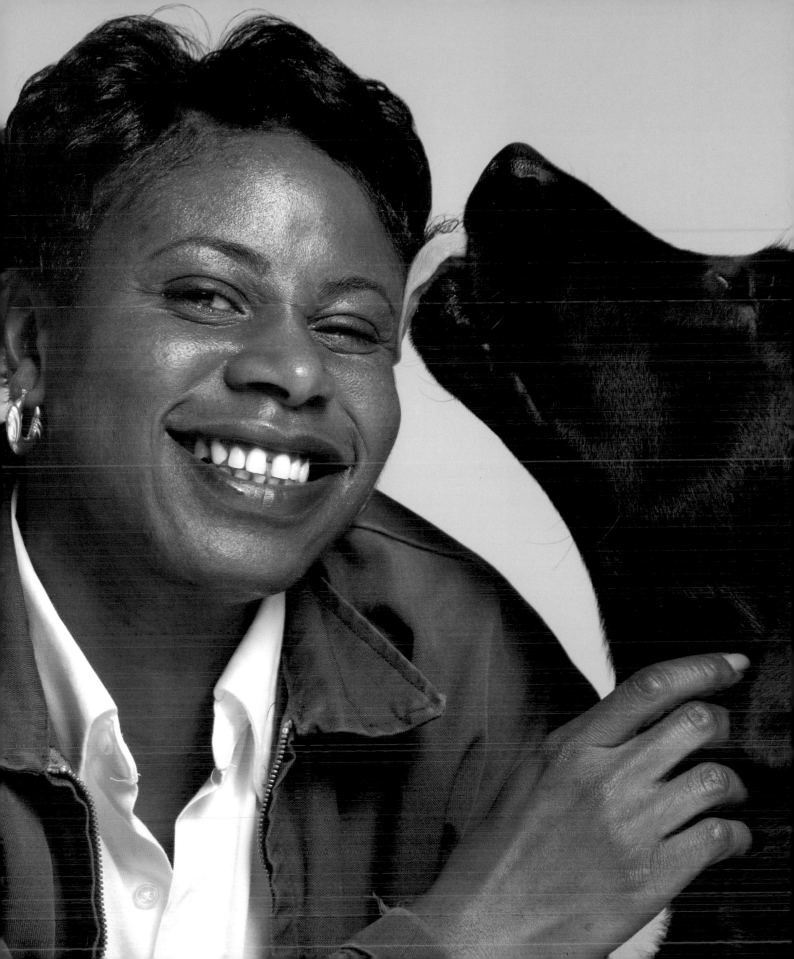

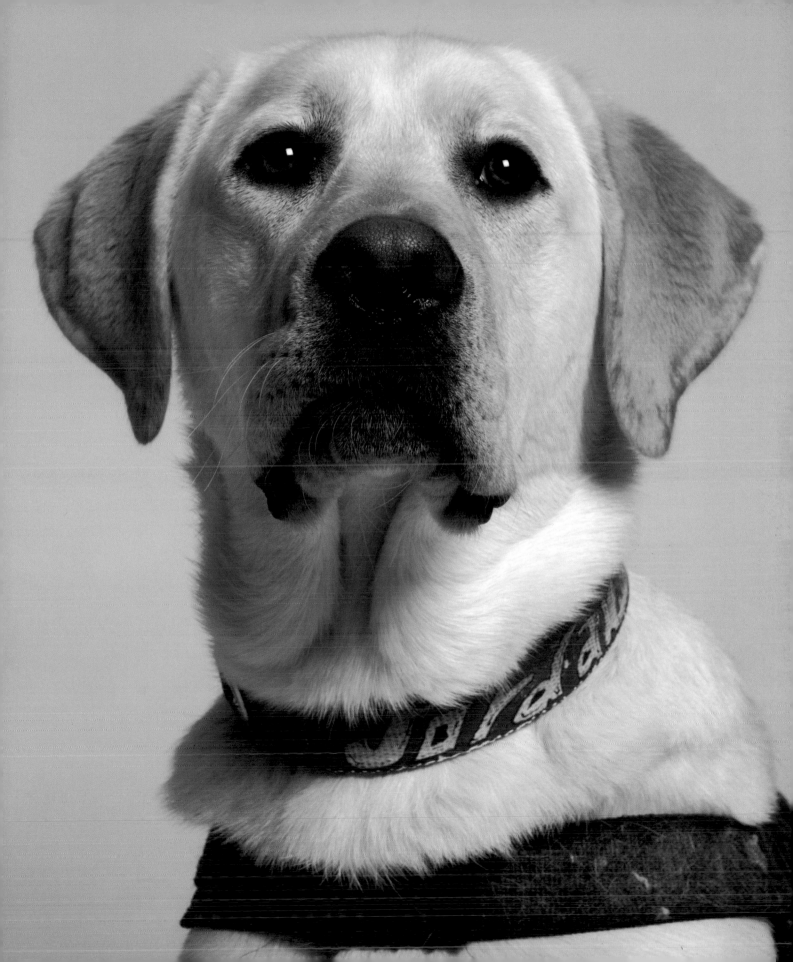

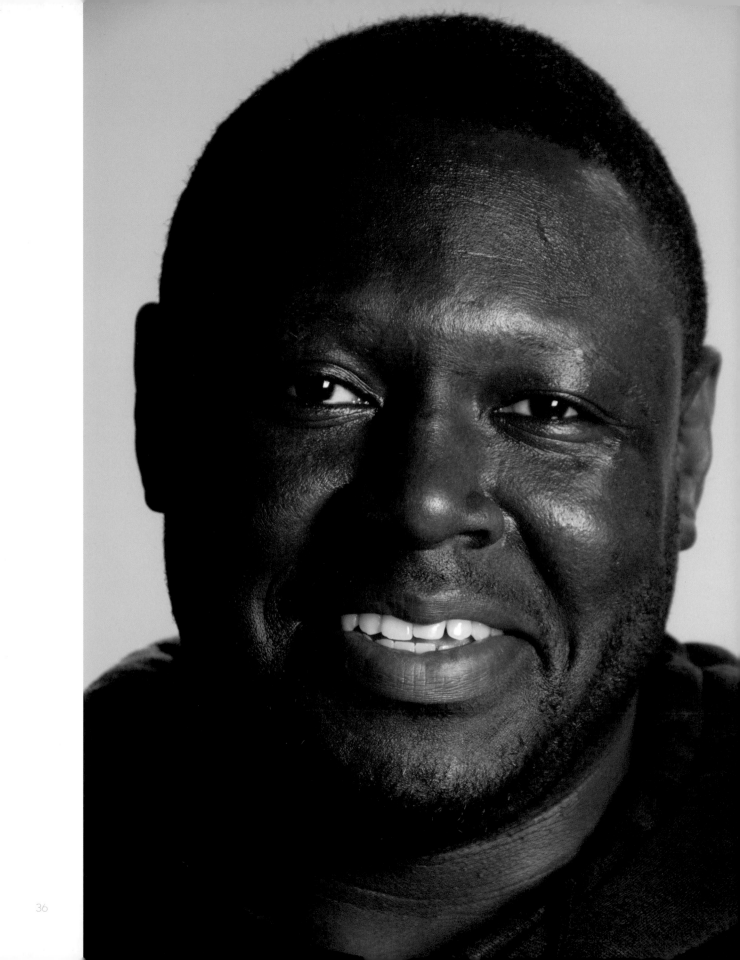

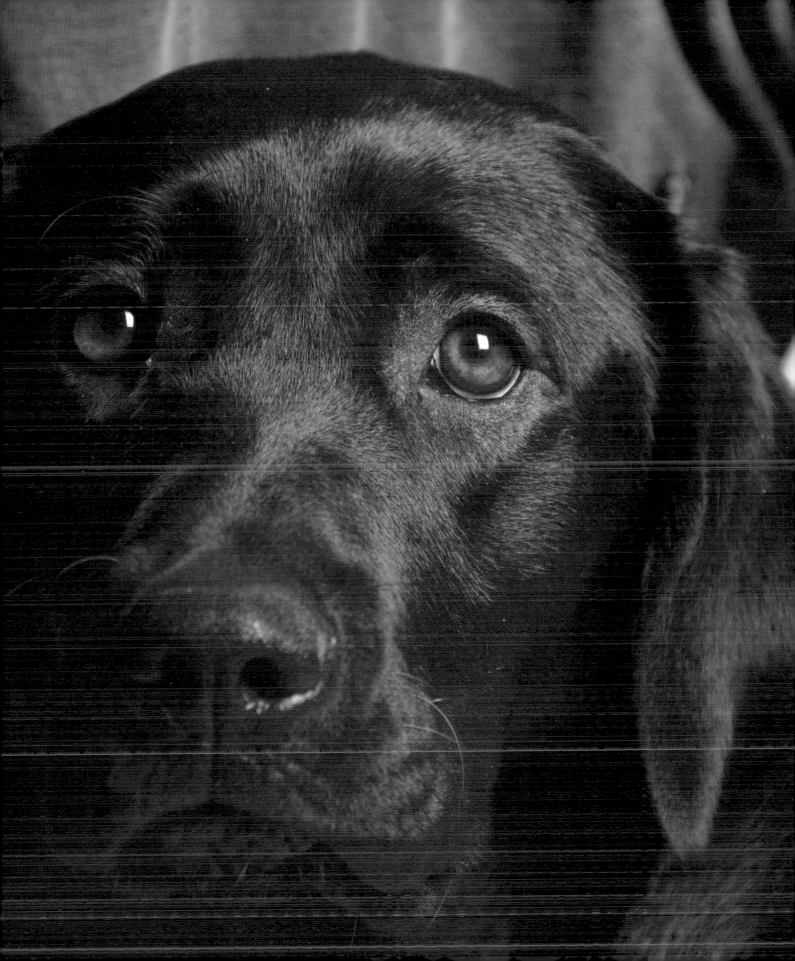

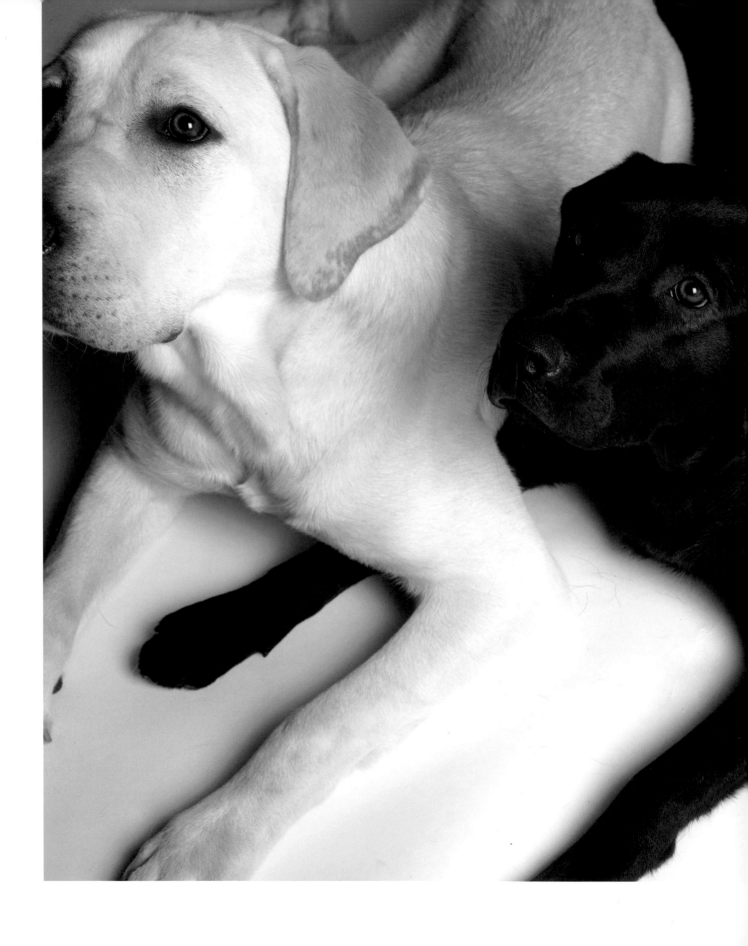

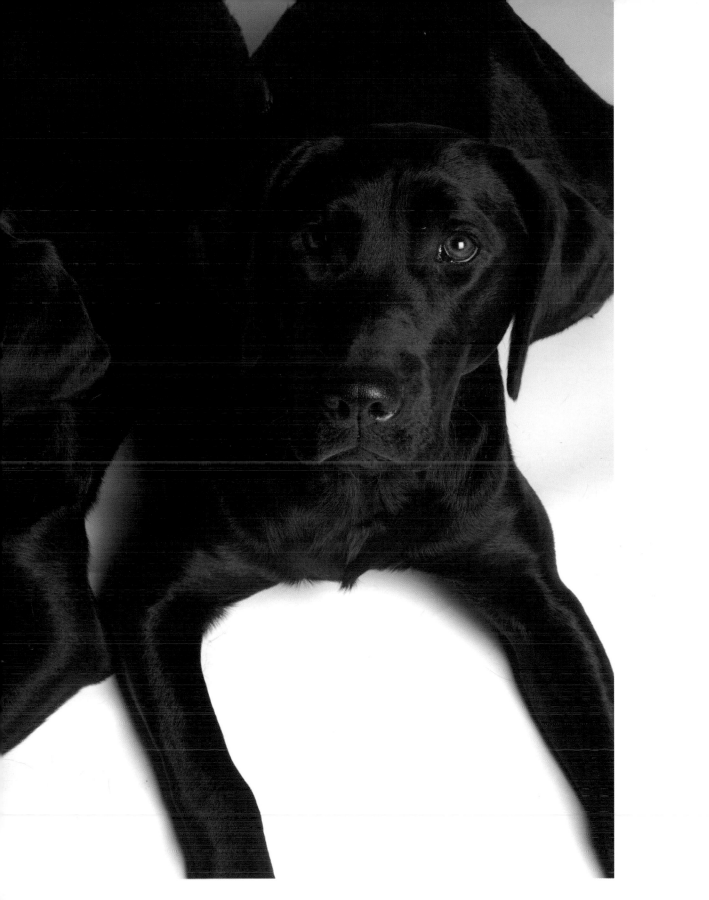

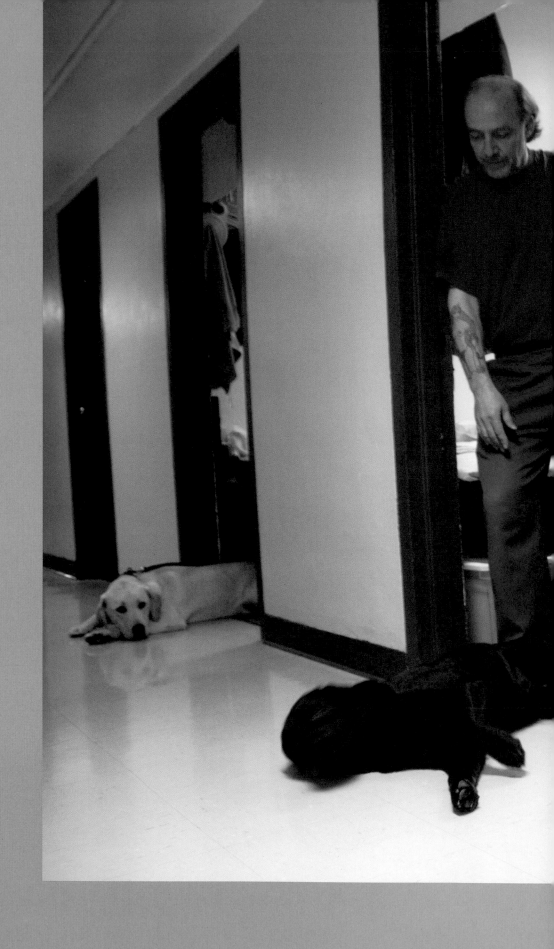

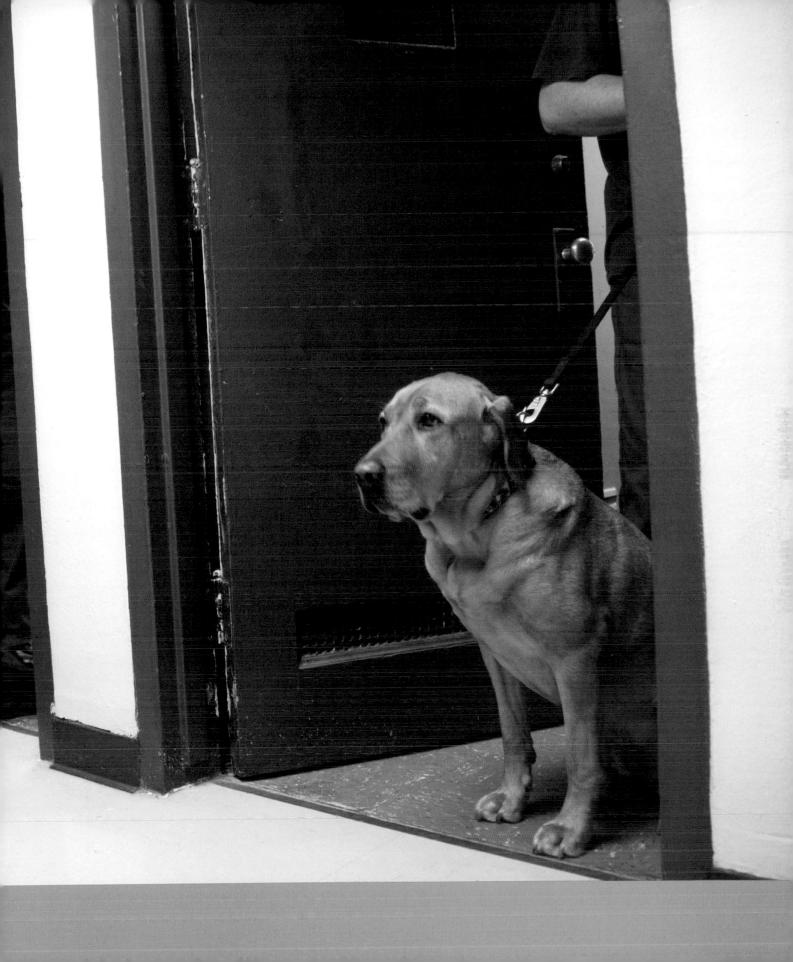

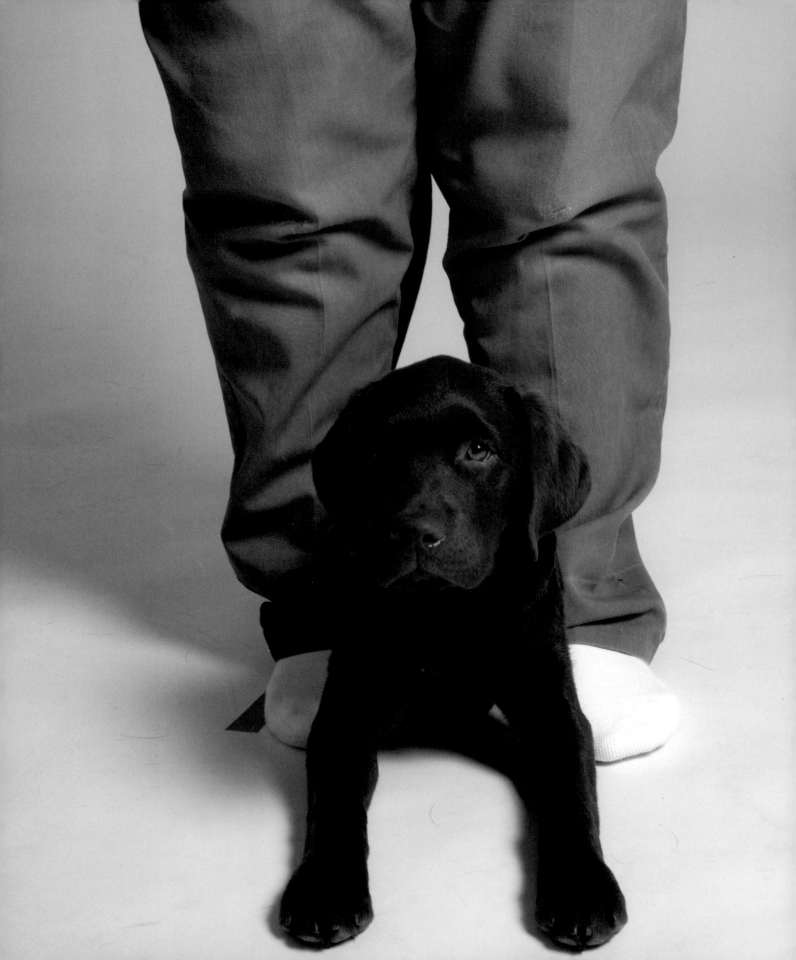

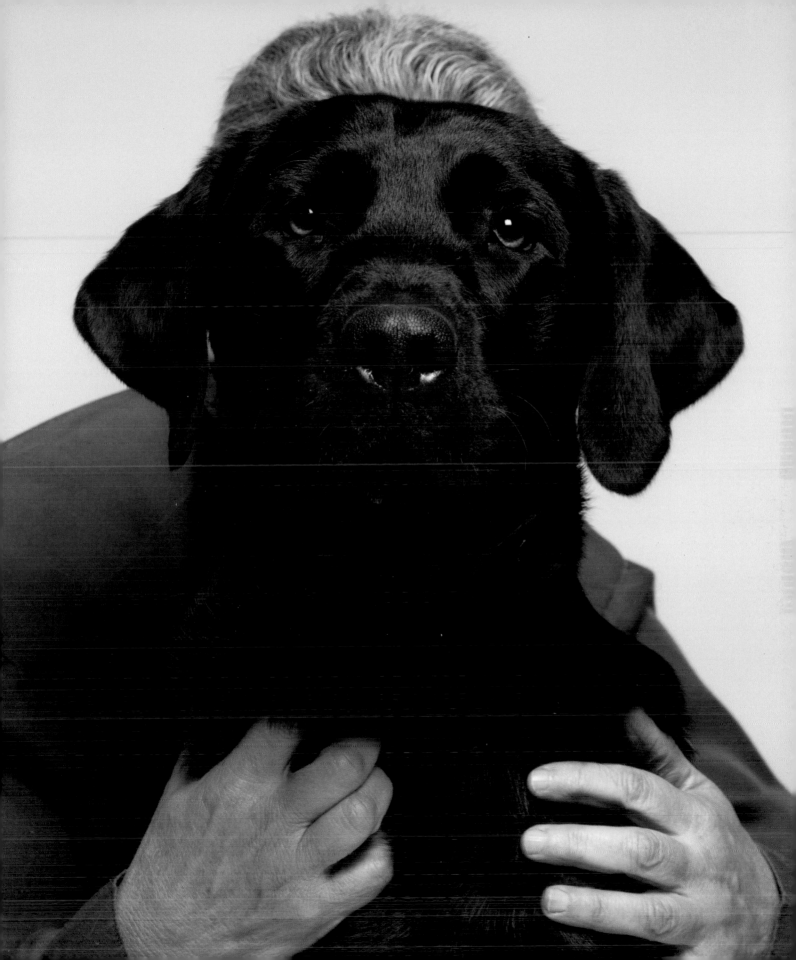

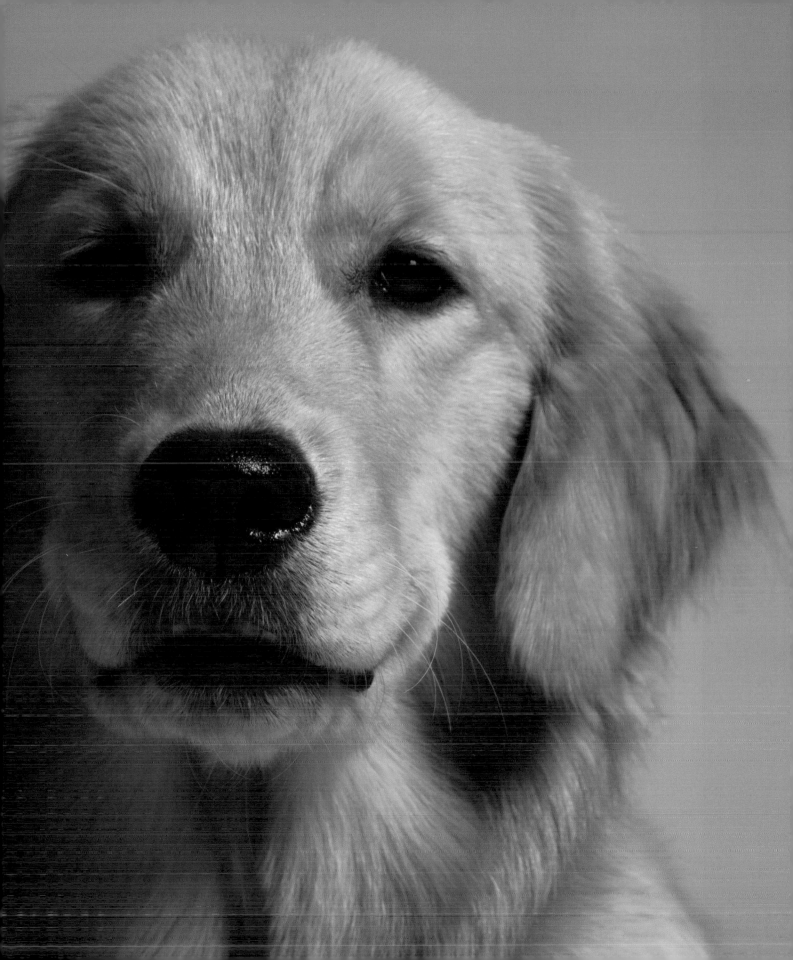

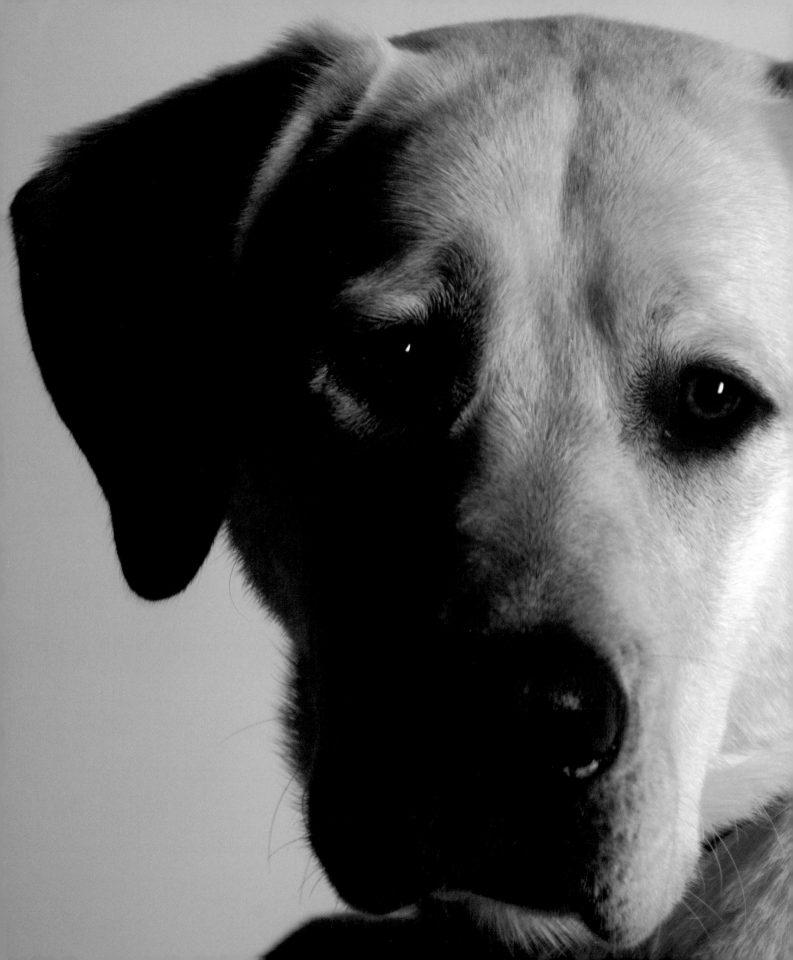

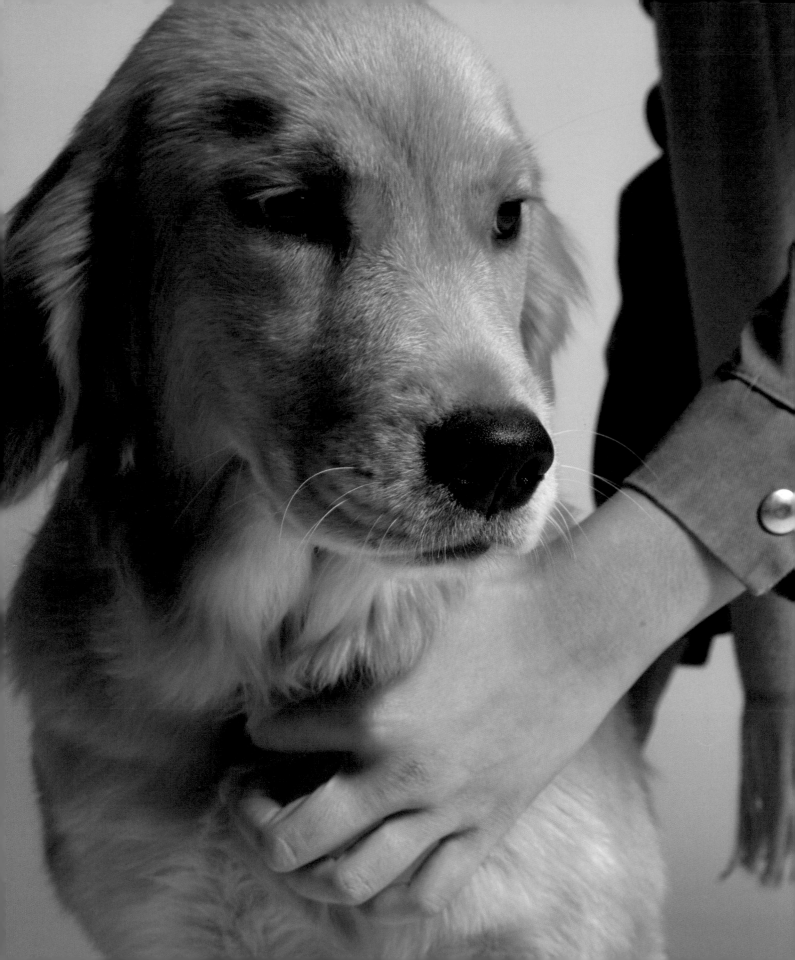

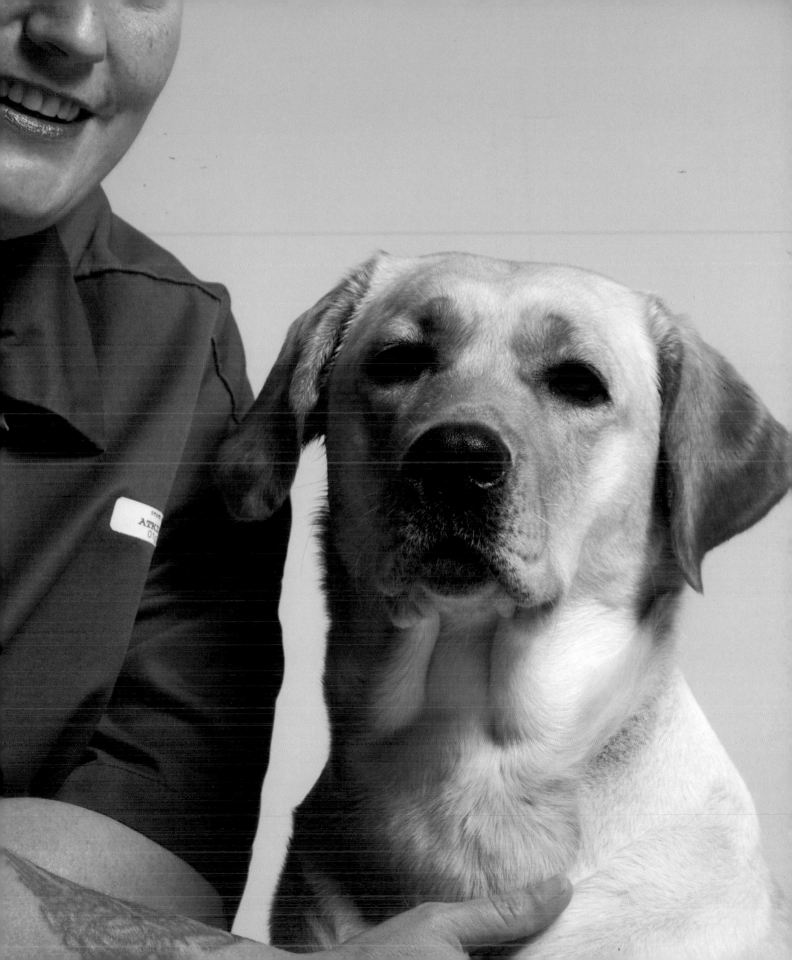

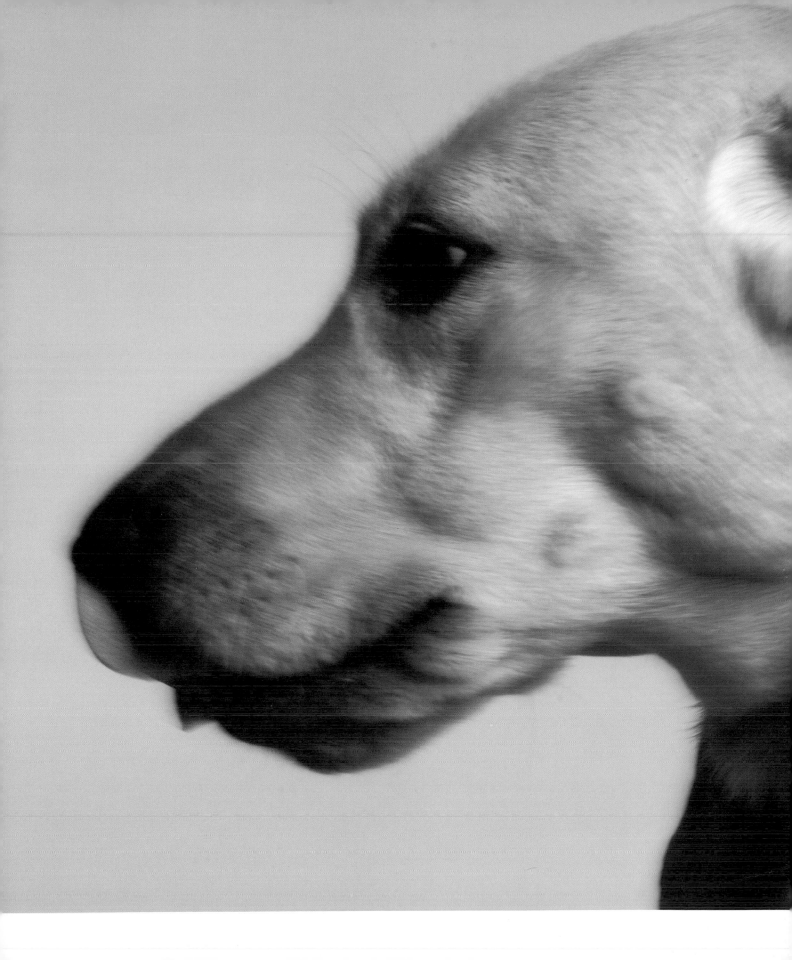

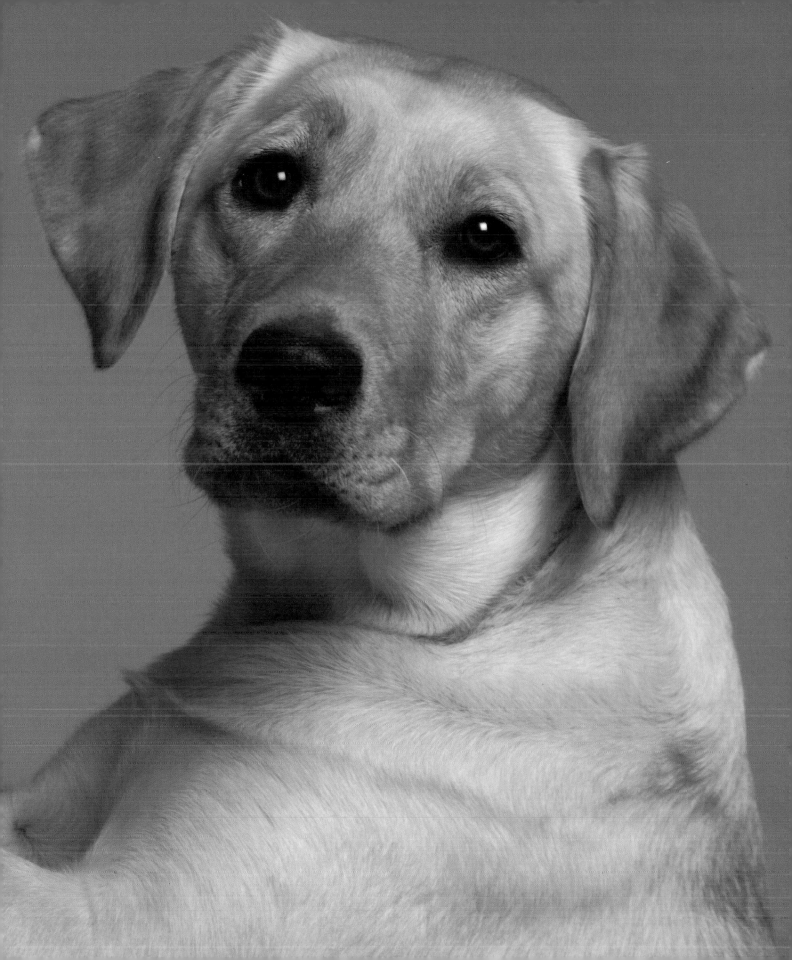

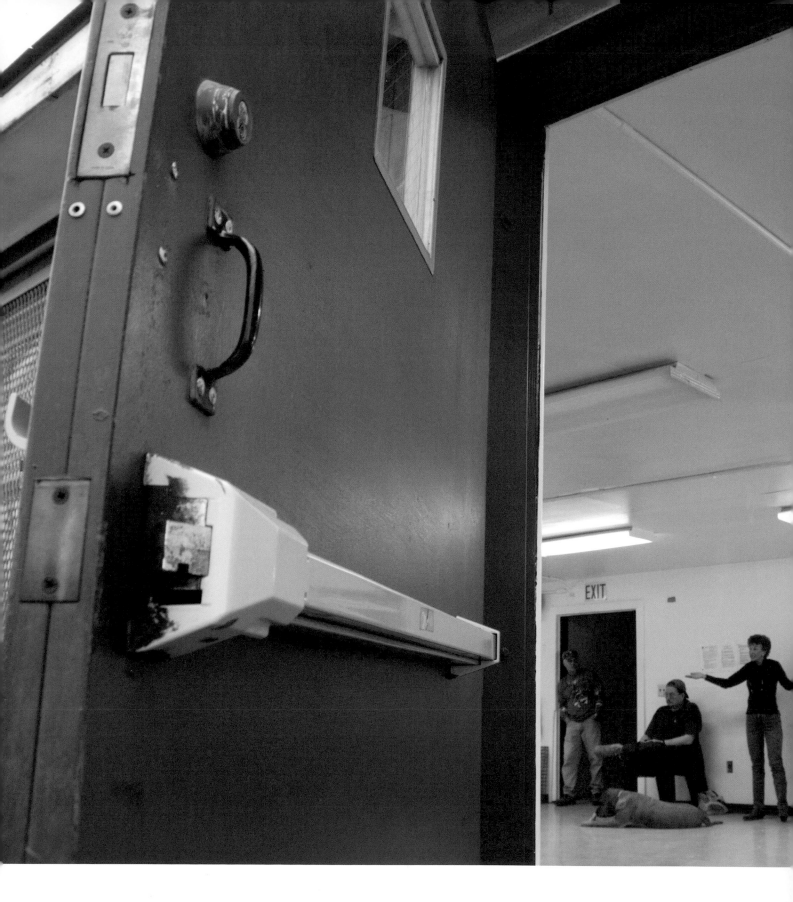

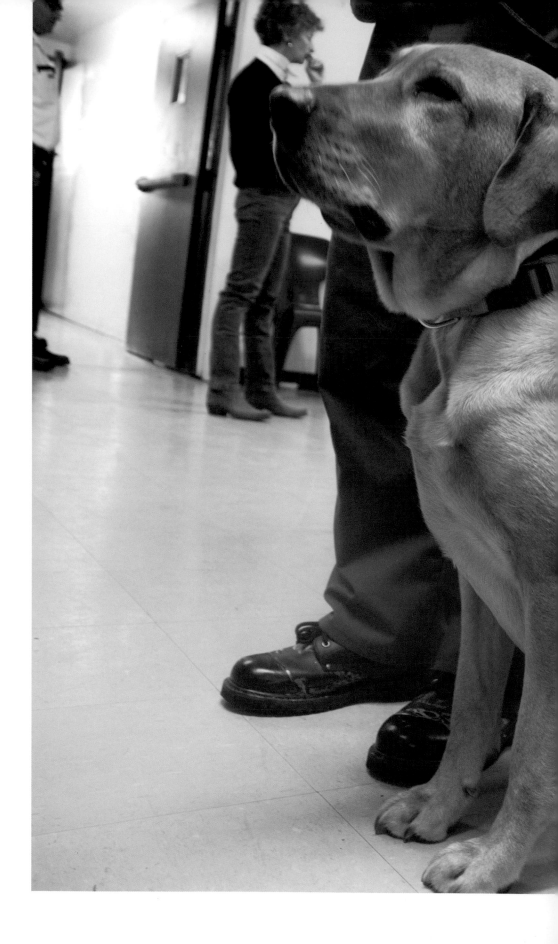

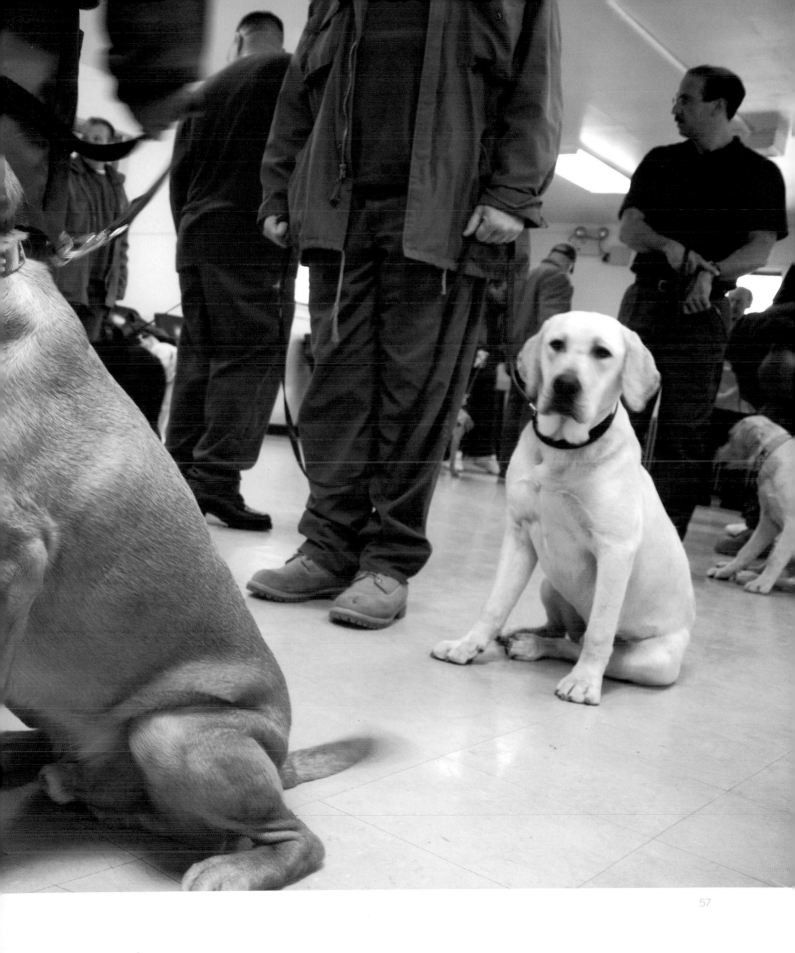

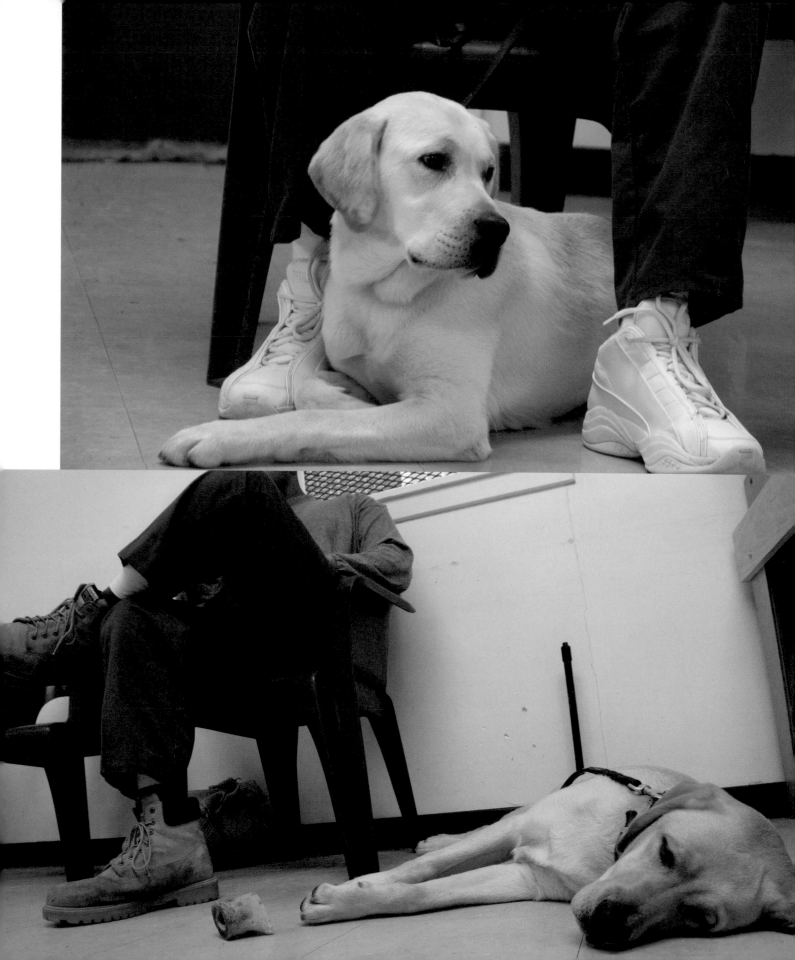

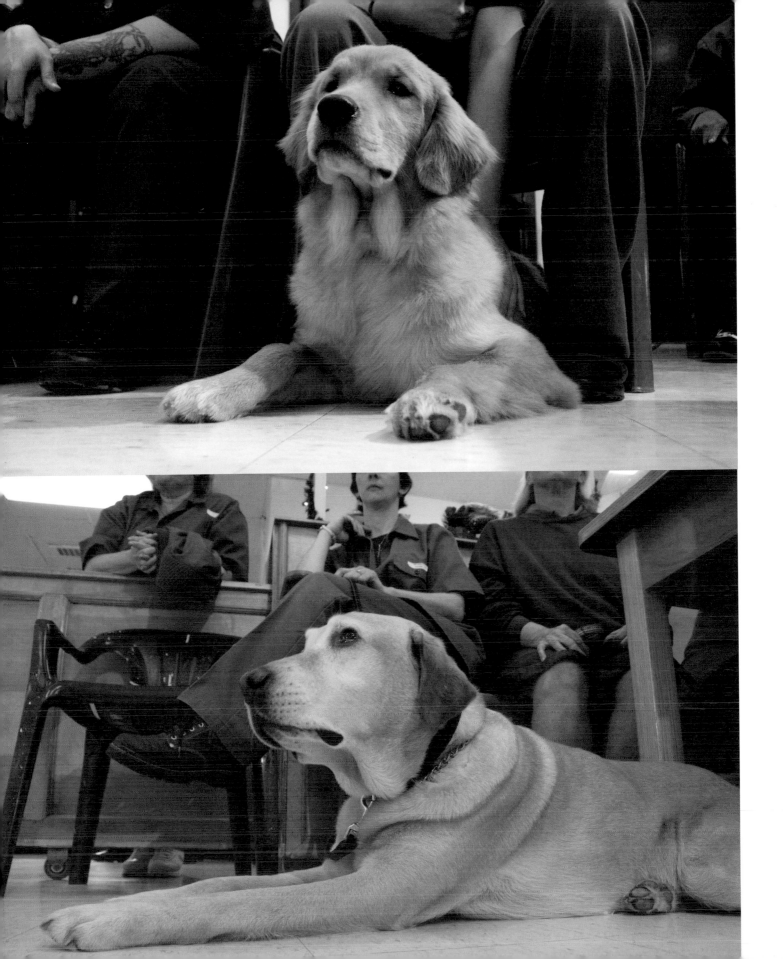

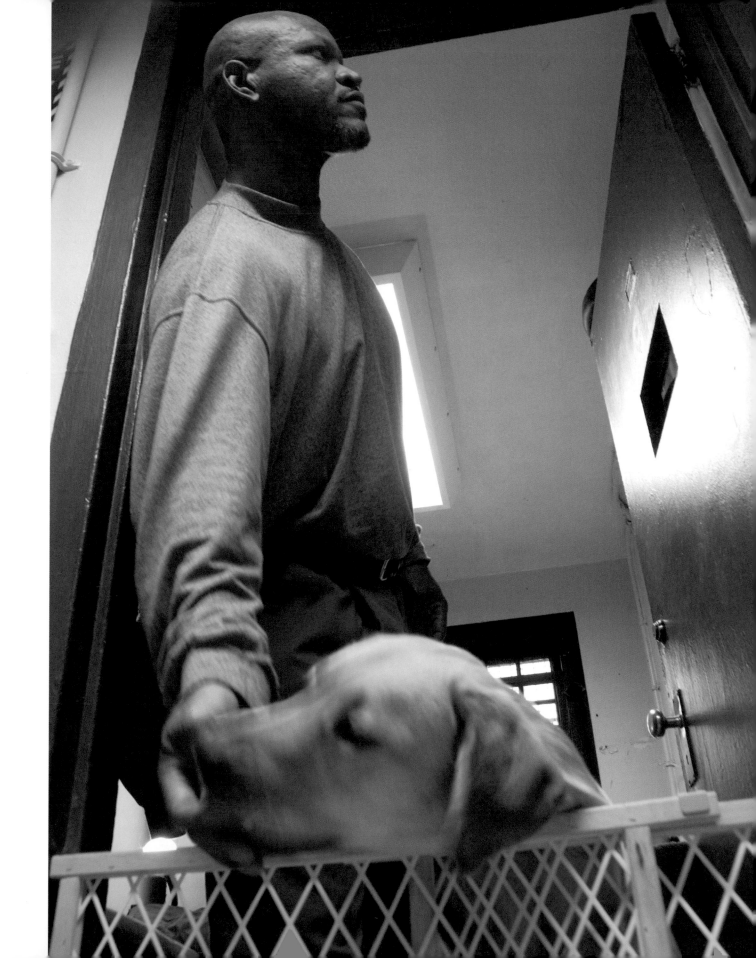

Won				
Prot				
Cath				
N.O.				
Ei...	...9/8/06	10/30/06	N/A	12/15/06

LATE ARRIV

KEY: (F...amily Event
(Inhouse) or (I) = Inmate Only Event

EVENtS CALE

treatment, please arrange to see a facility health care provide...

Hep. C

PuPPY Rec.

Counselors

6. DO NOT allow yourself to be bullied by anyone — you will get ...
 a situation that you may not be able to control.

APPROVED TO POST: _____
 A. Perez, Superinten...

REISSUED: 4/5/06

Sexual misconduct

sexual conduct

...u Resenten...

63

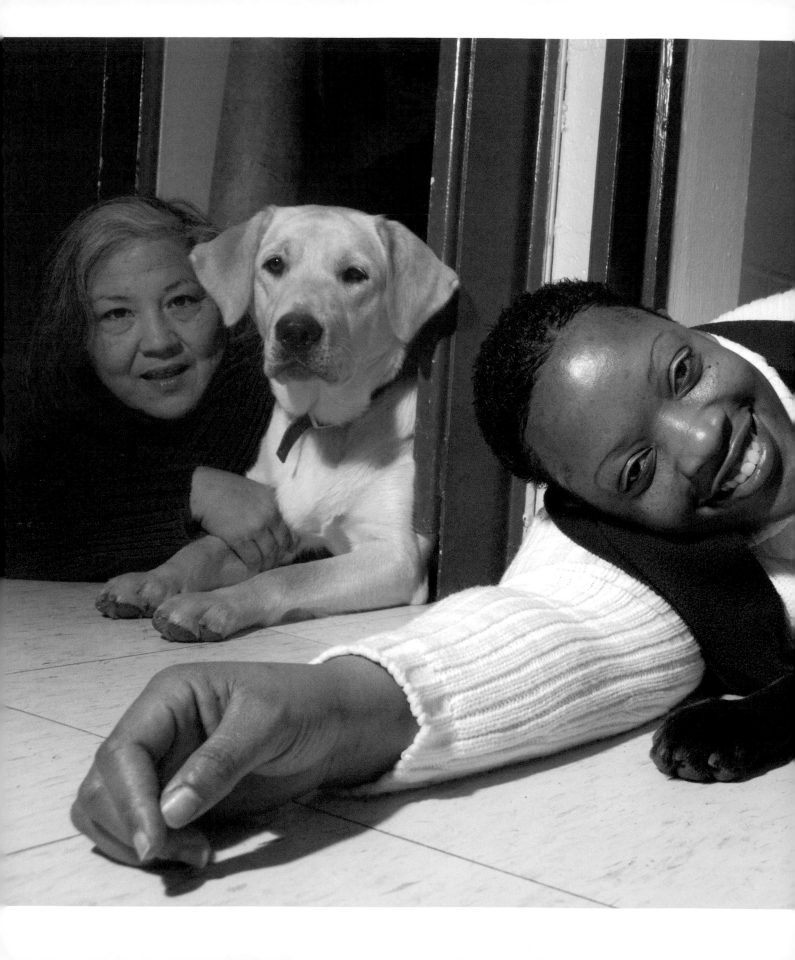

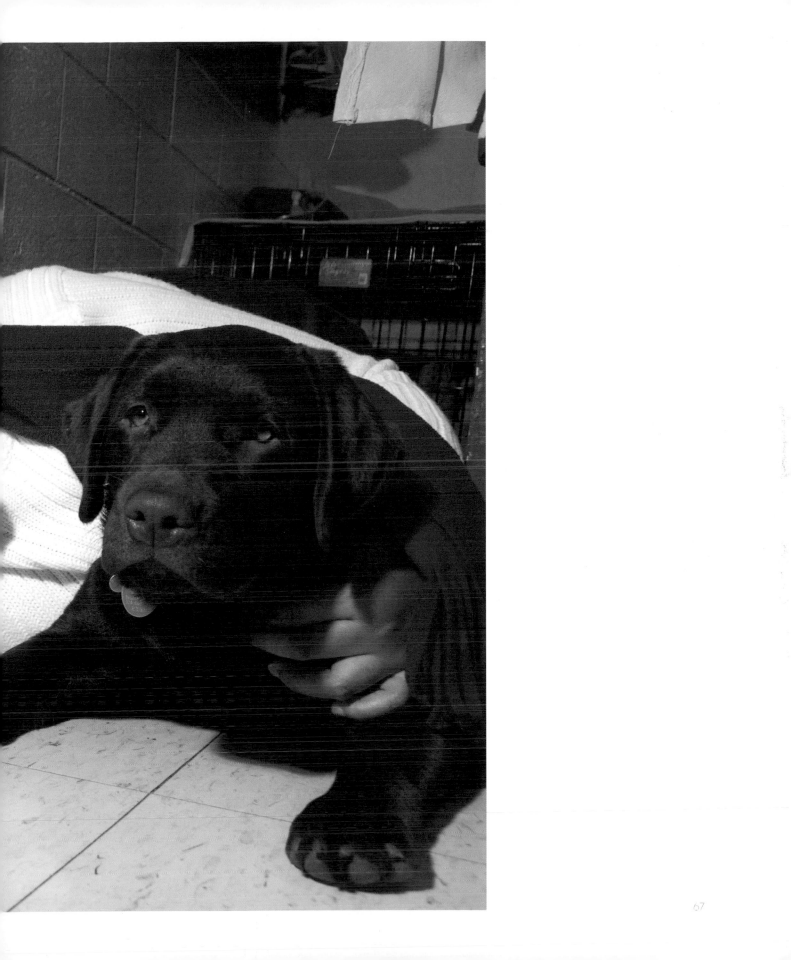

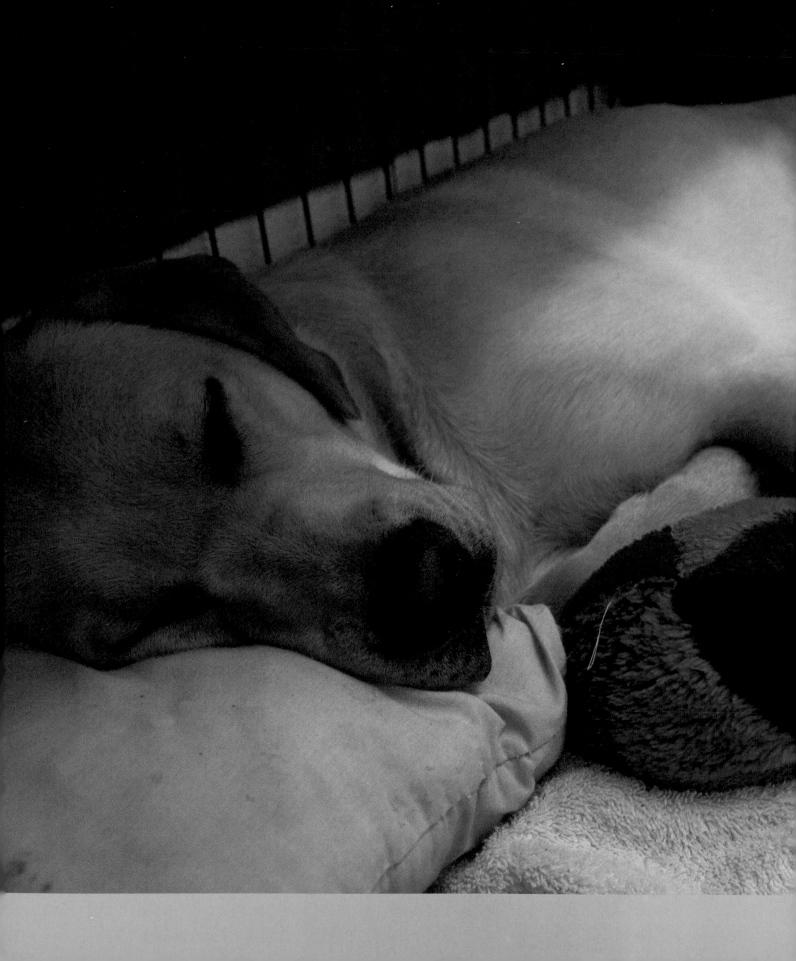

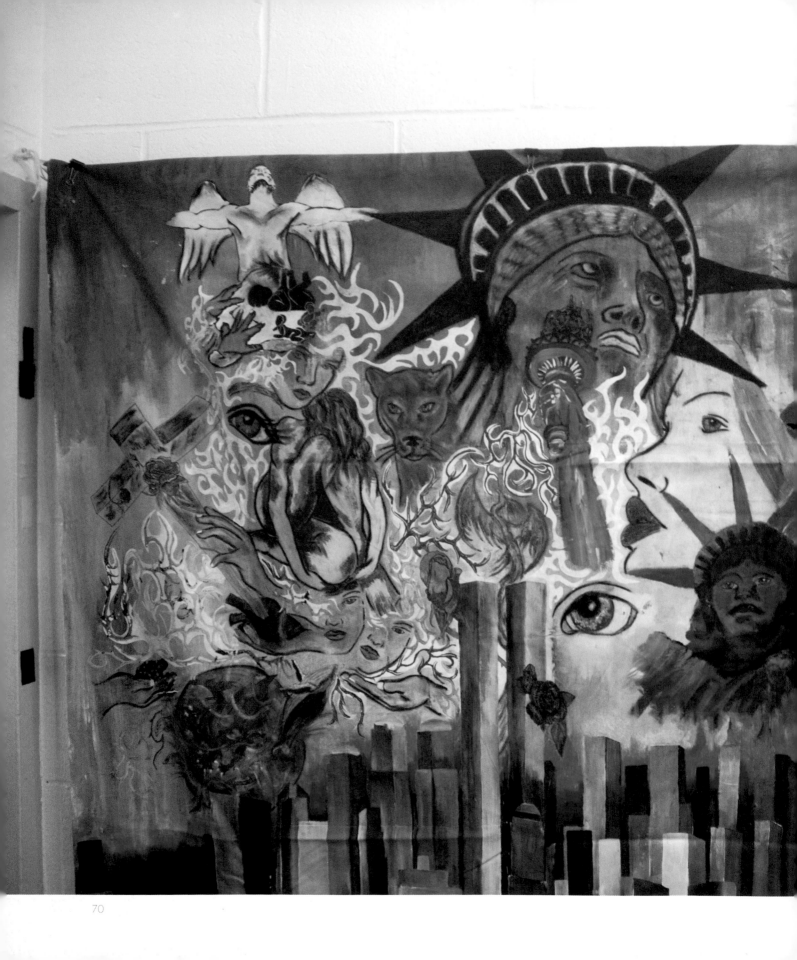

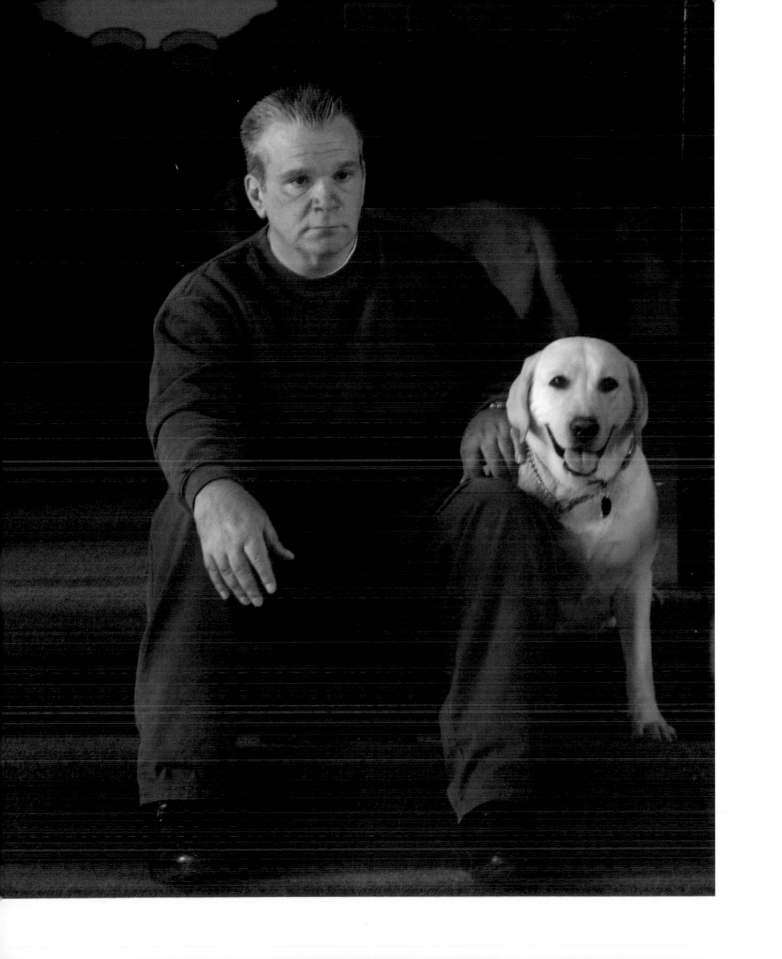

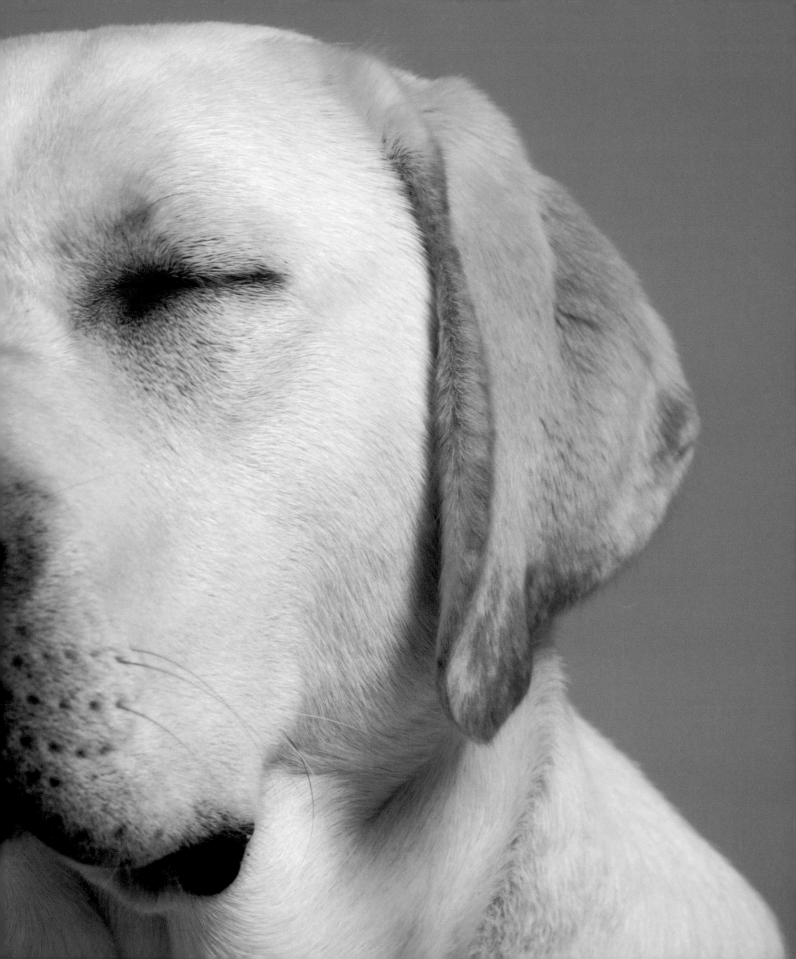

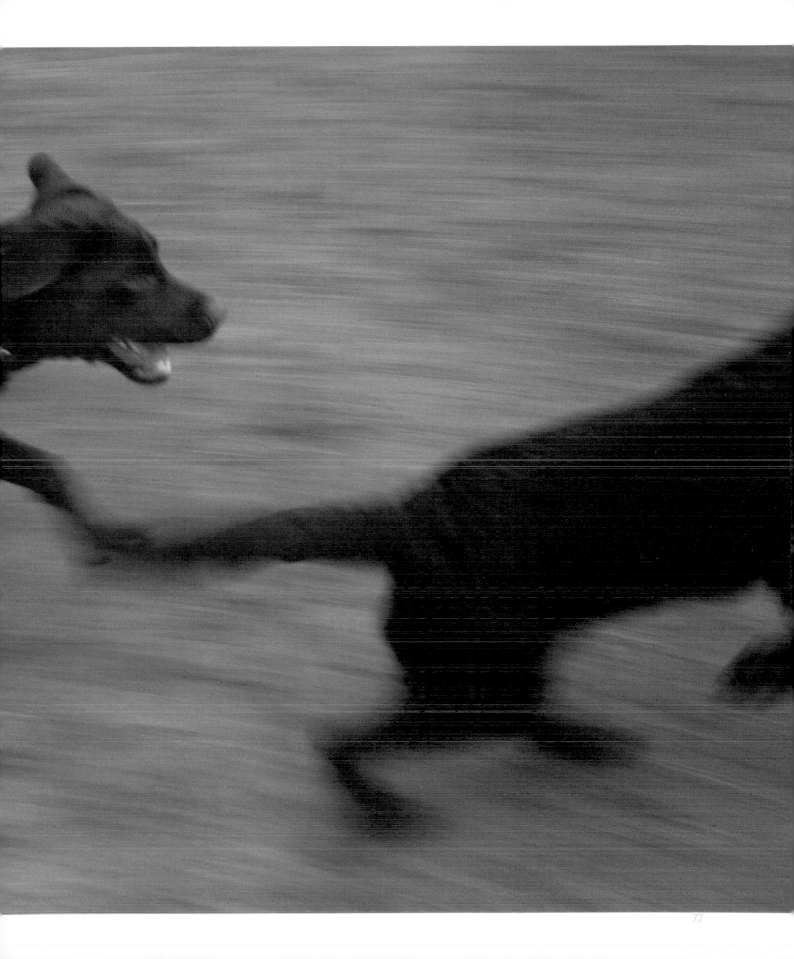

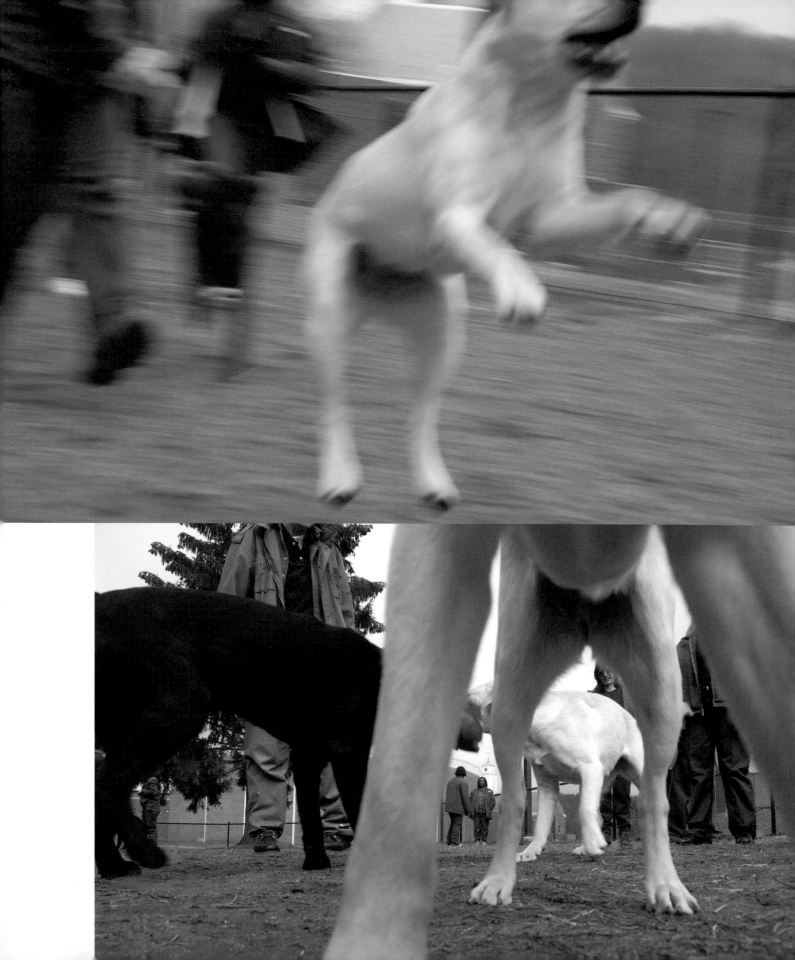

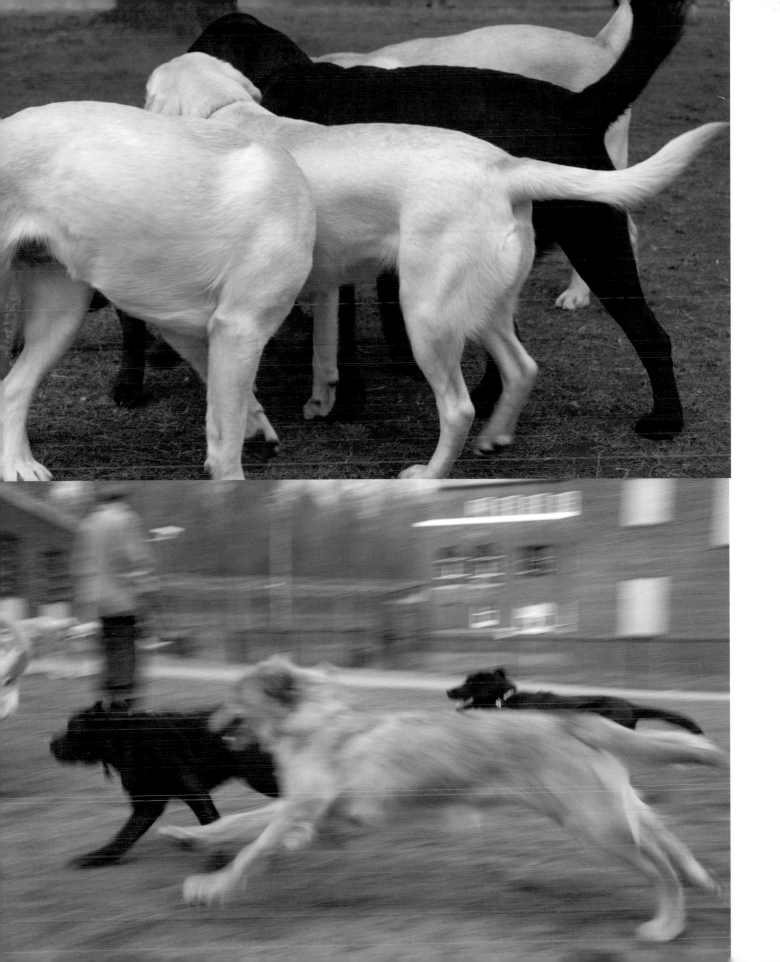

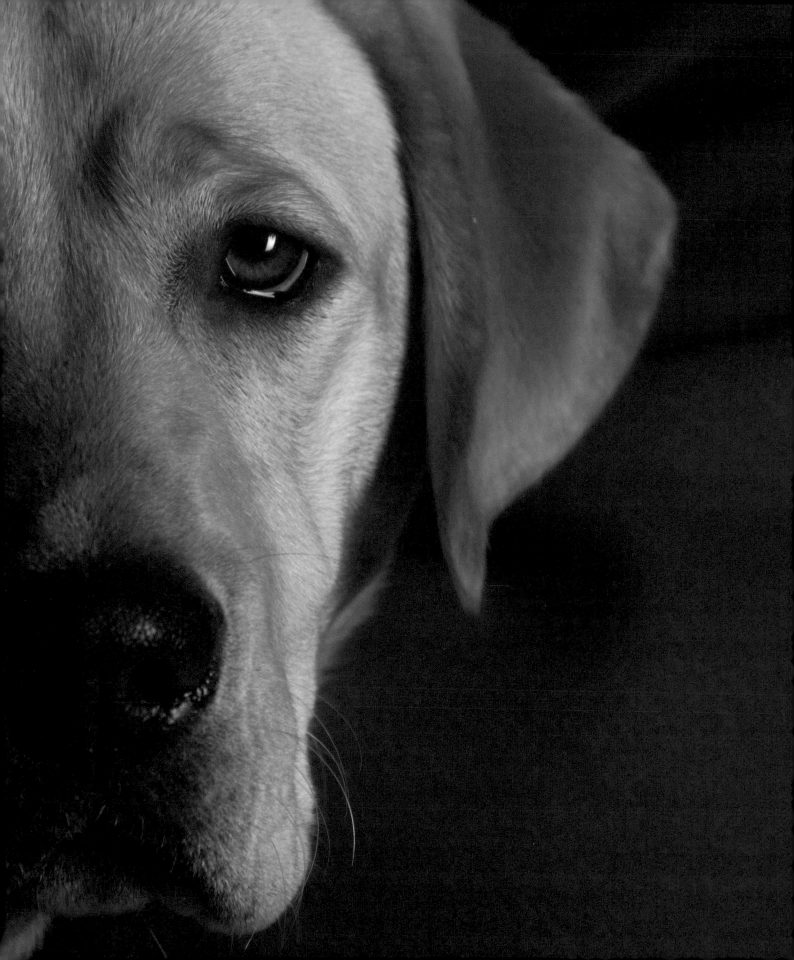

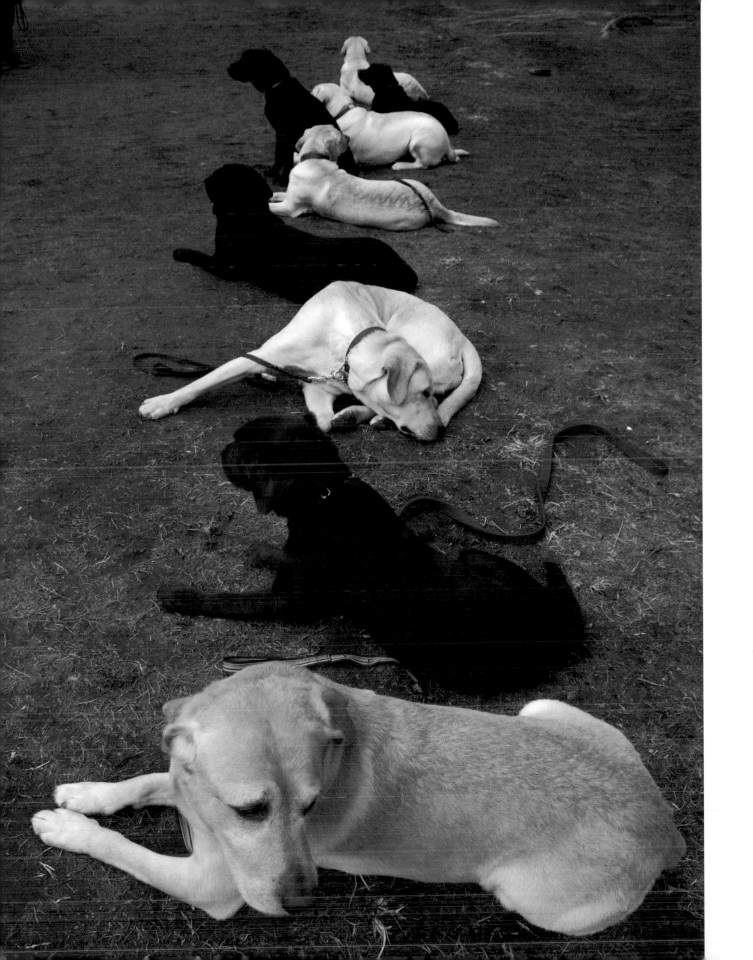

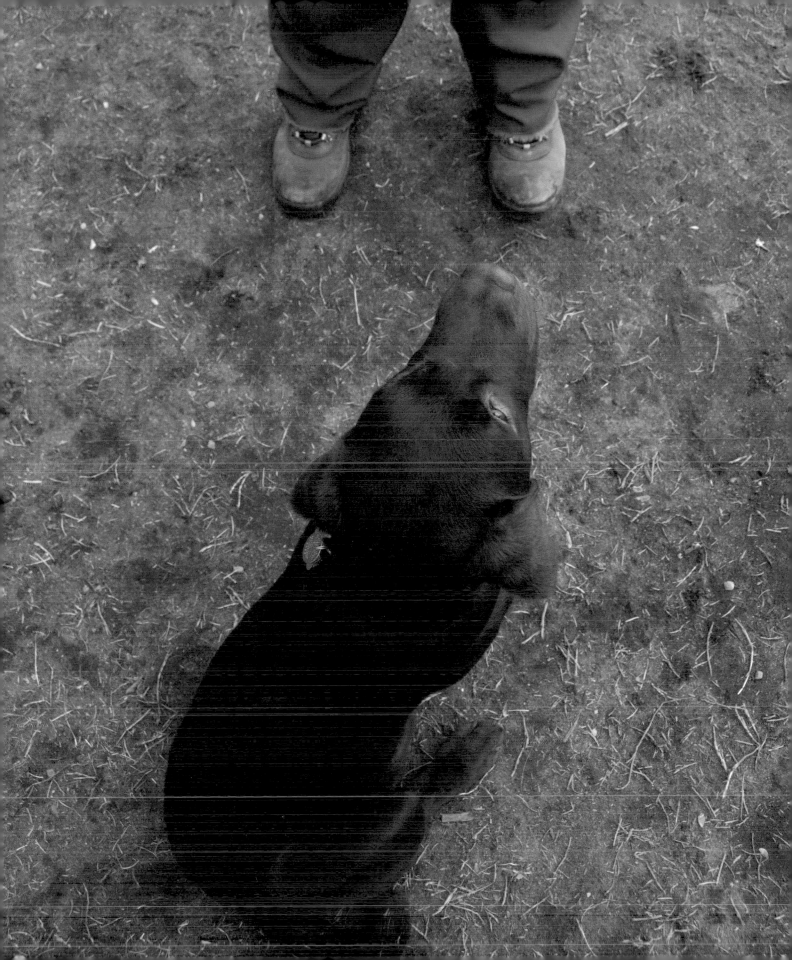

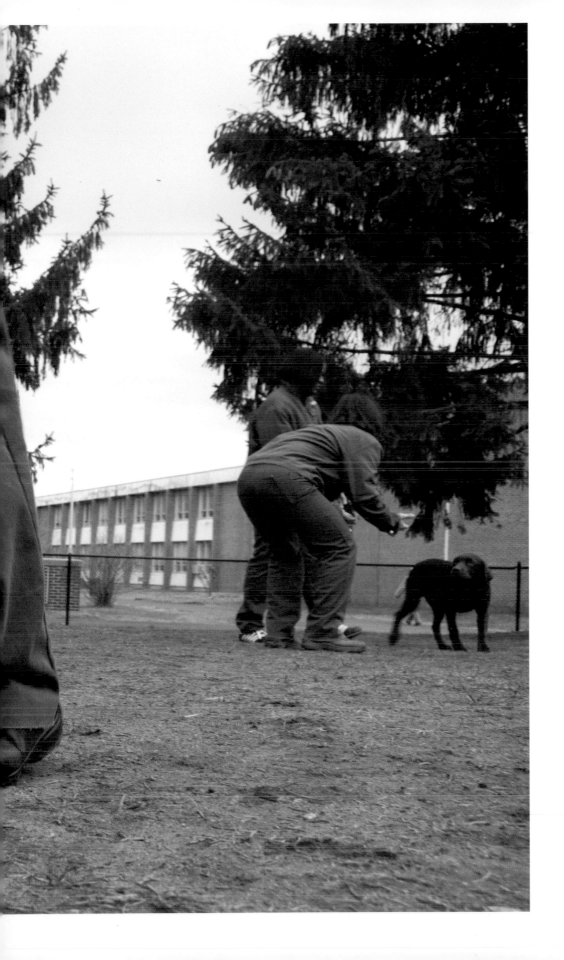

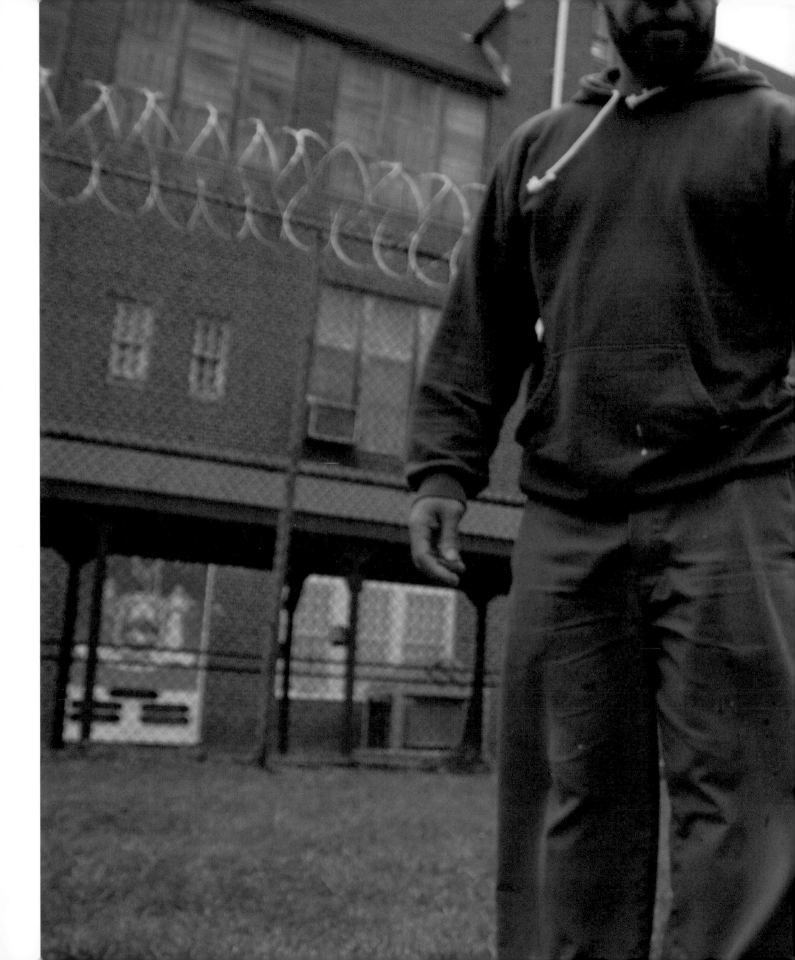

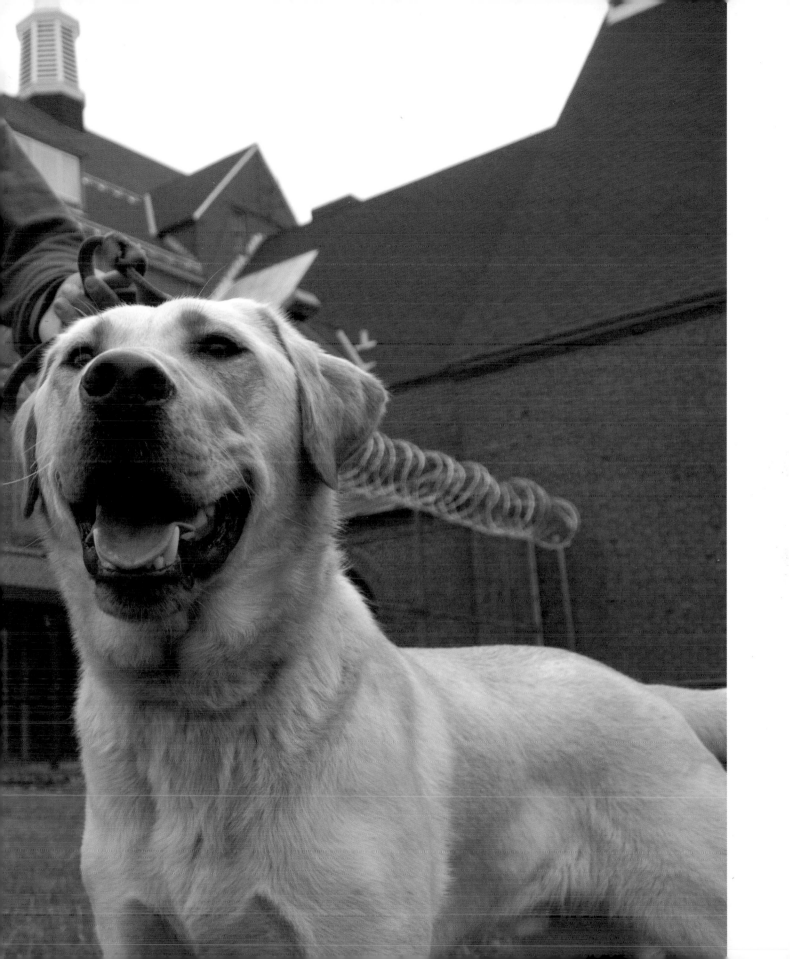

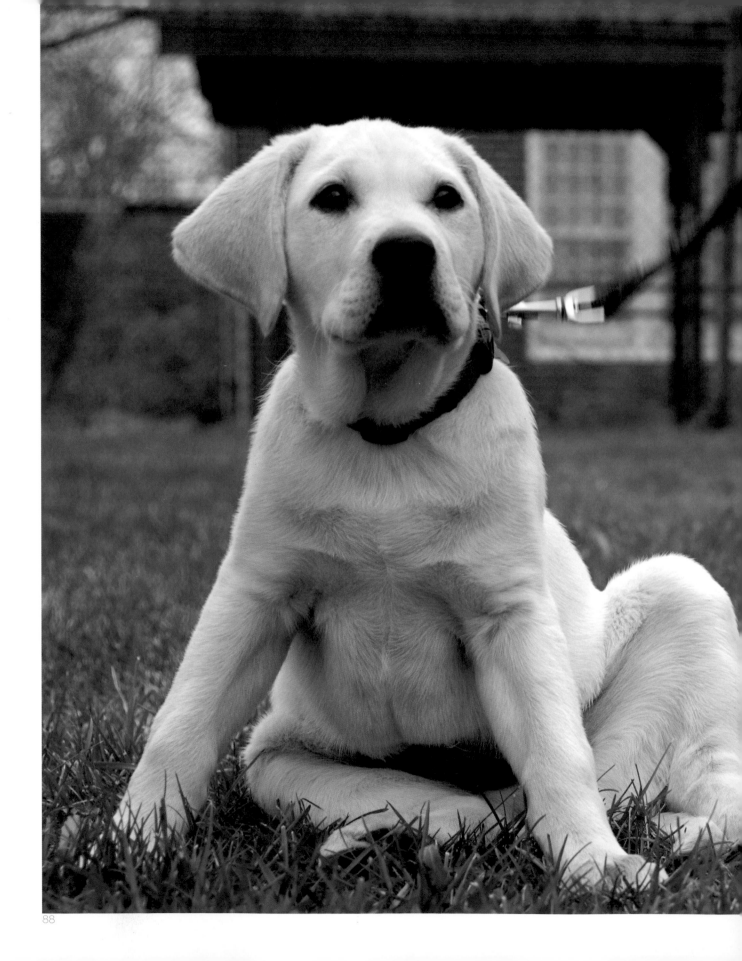

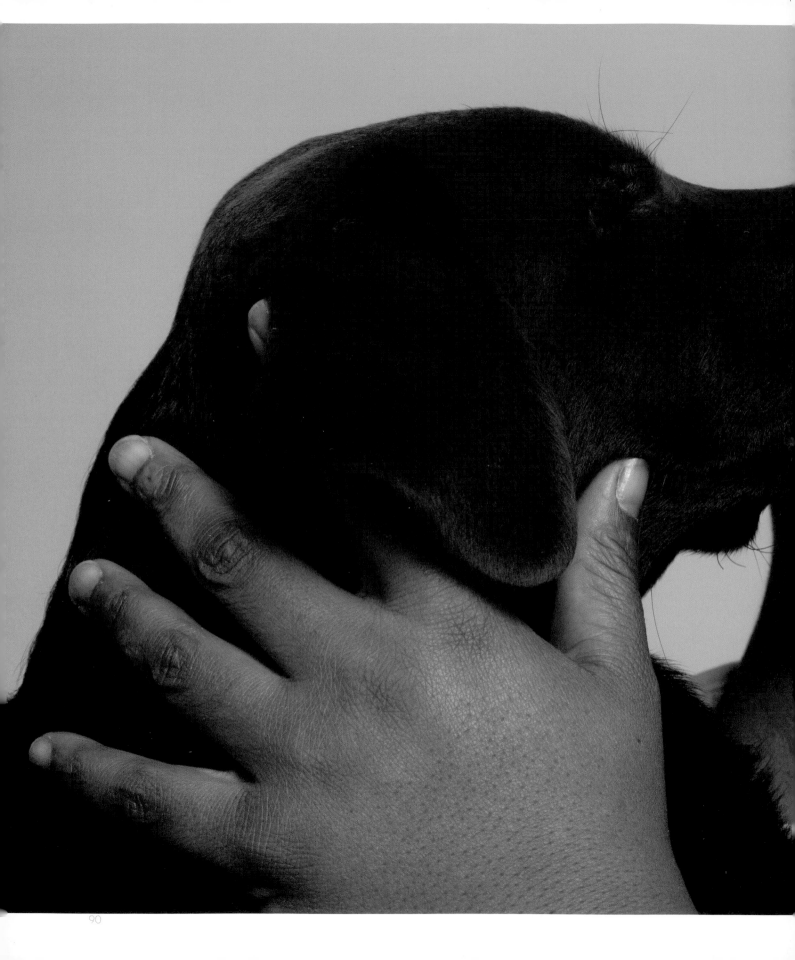

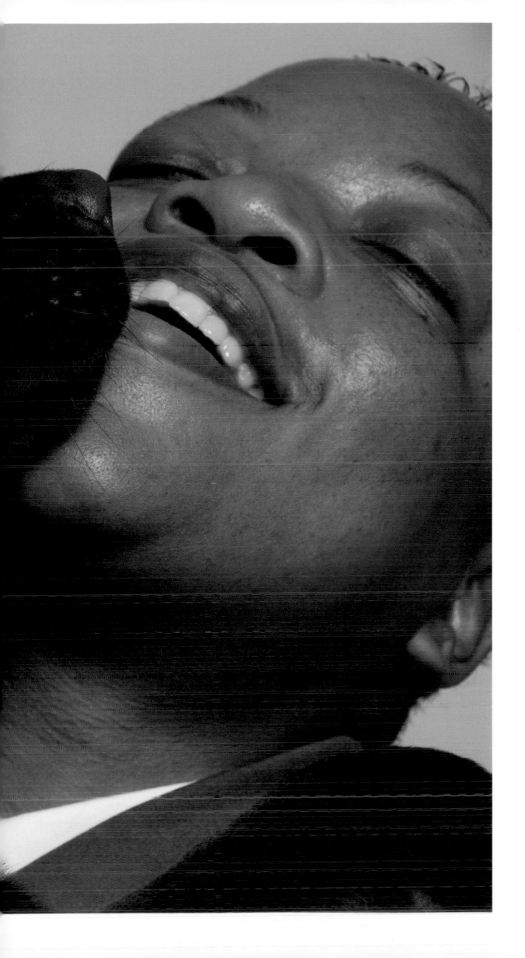

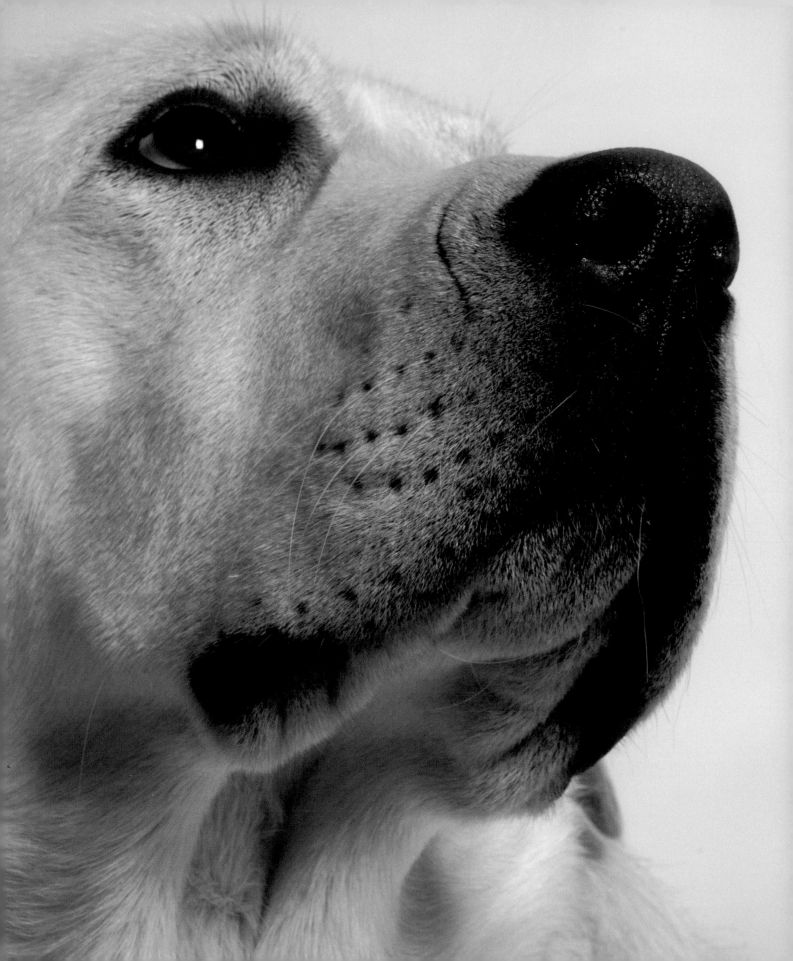

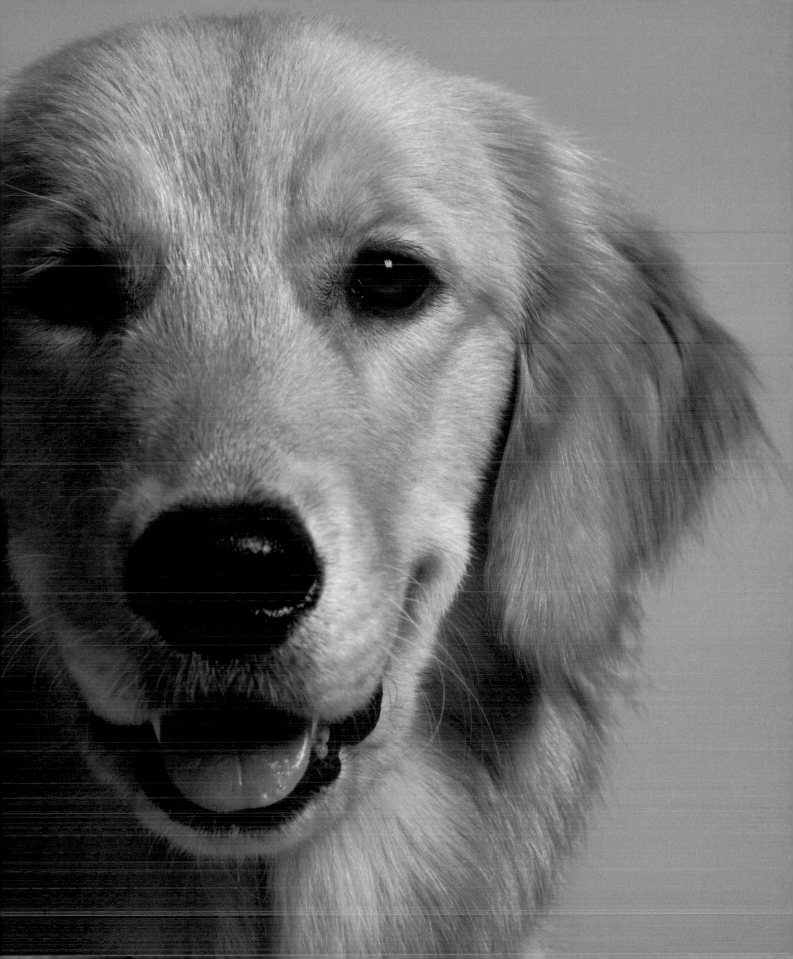

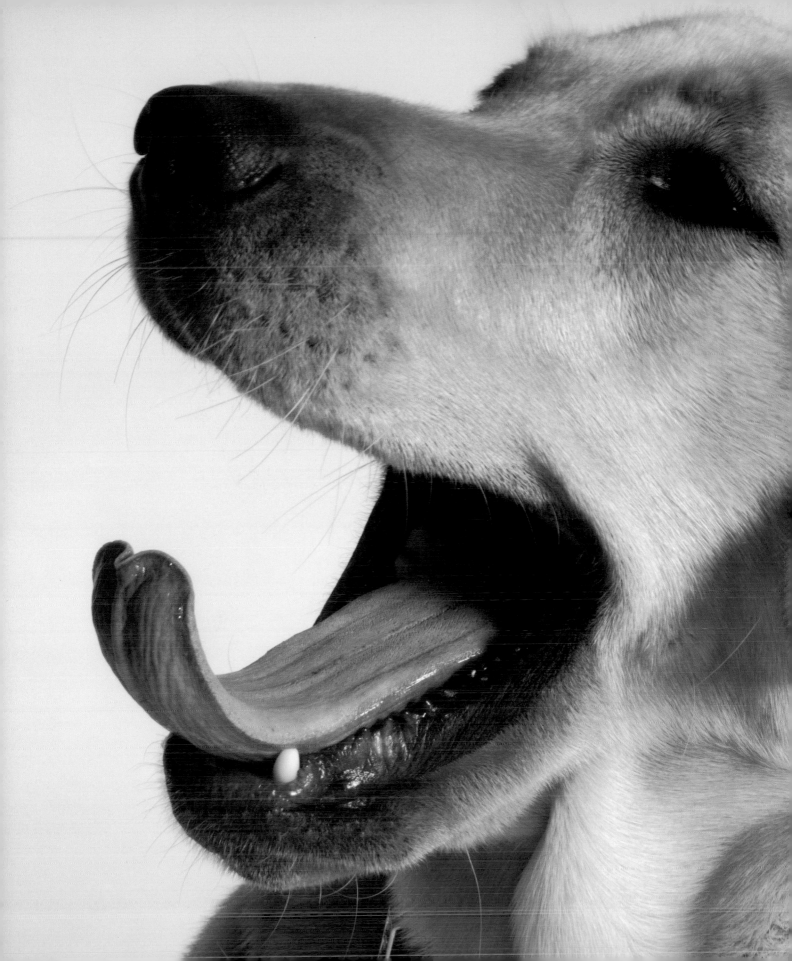

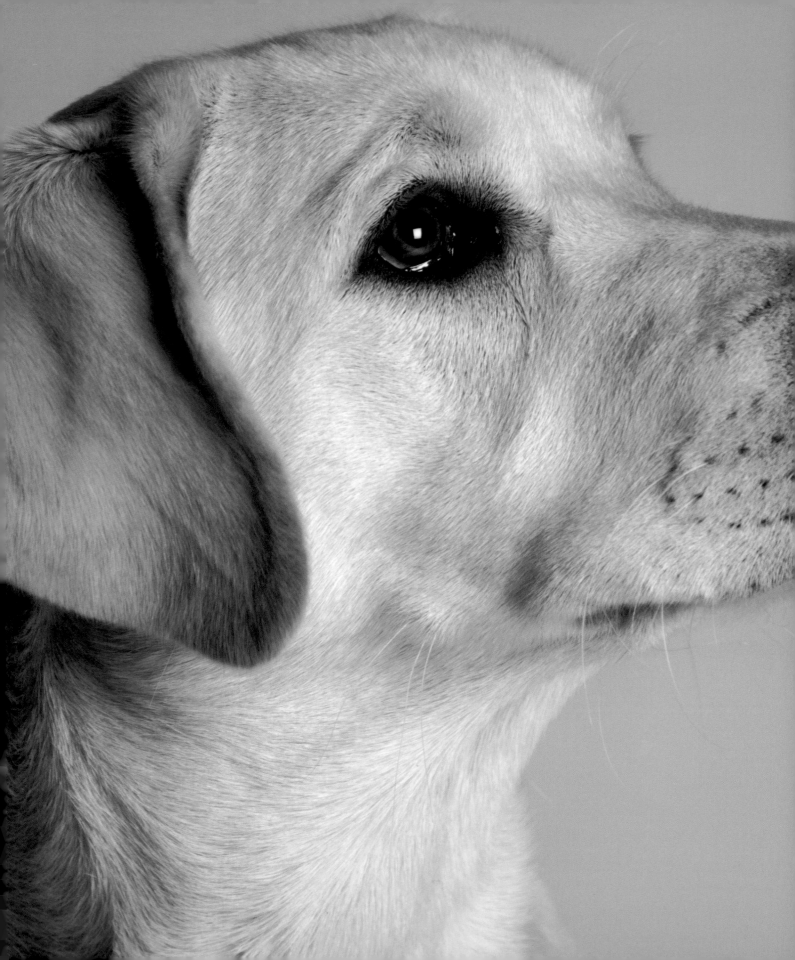

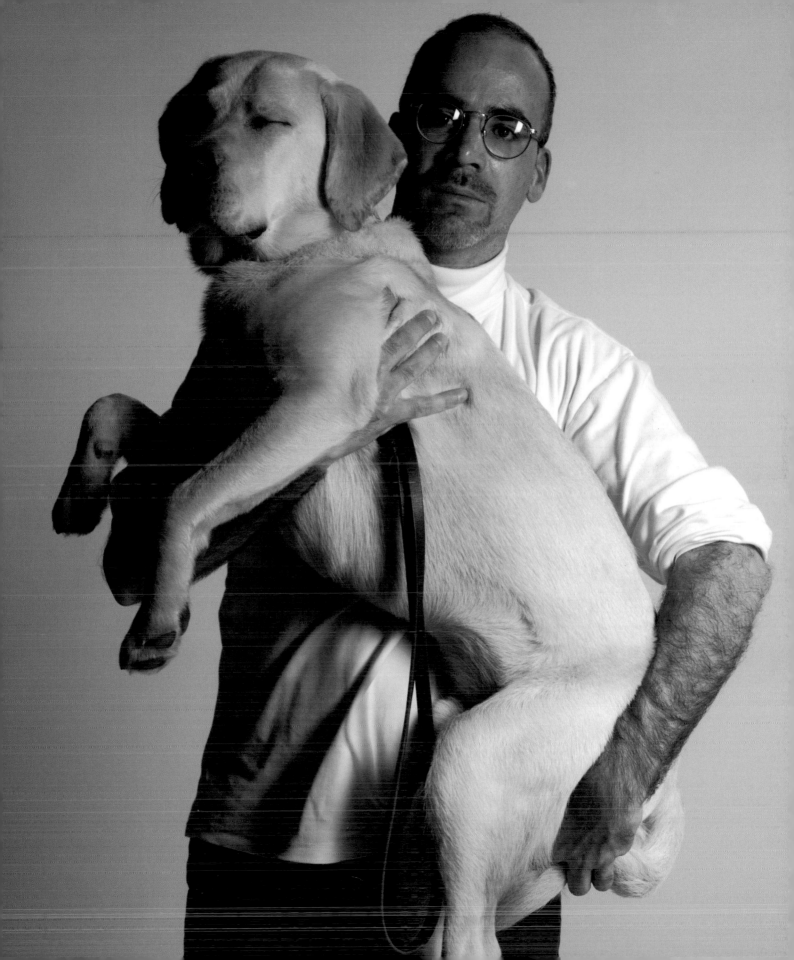

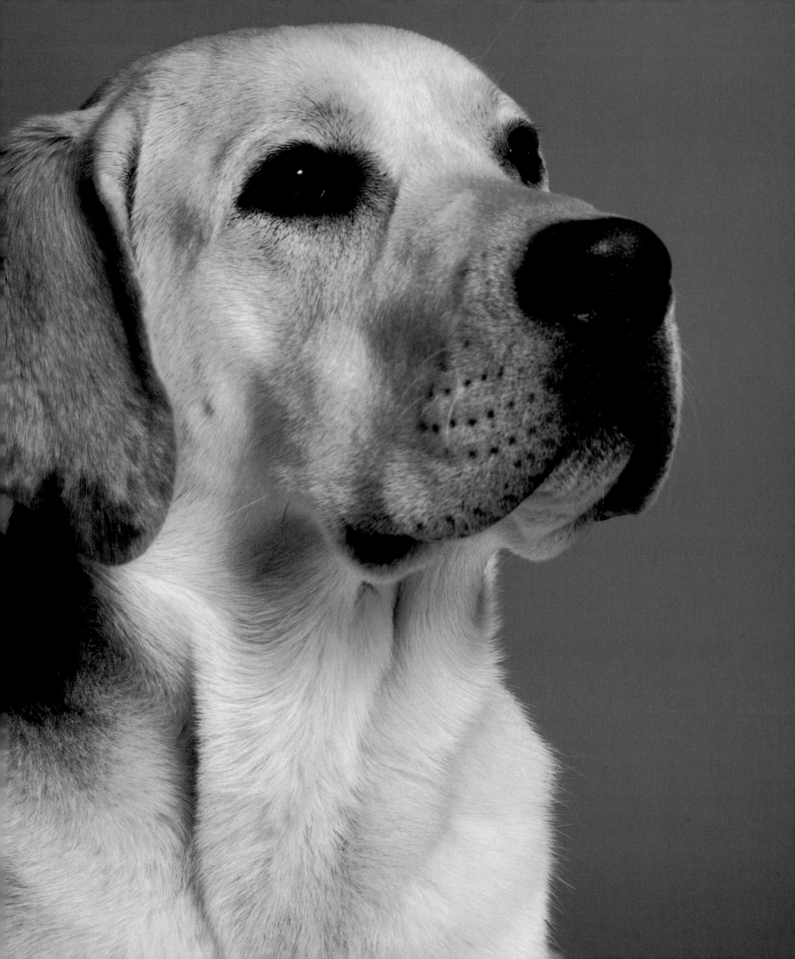

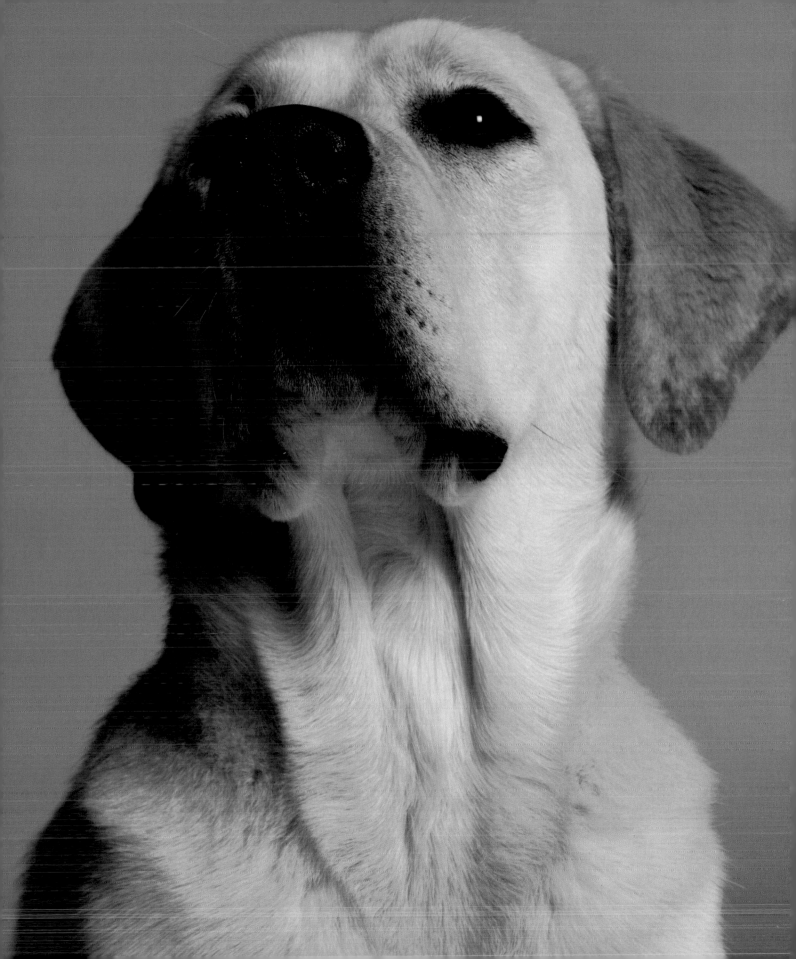

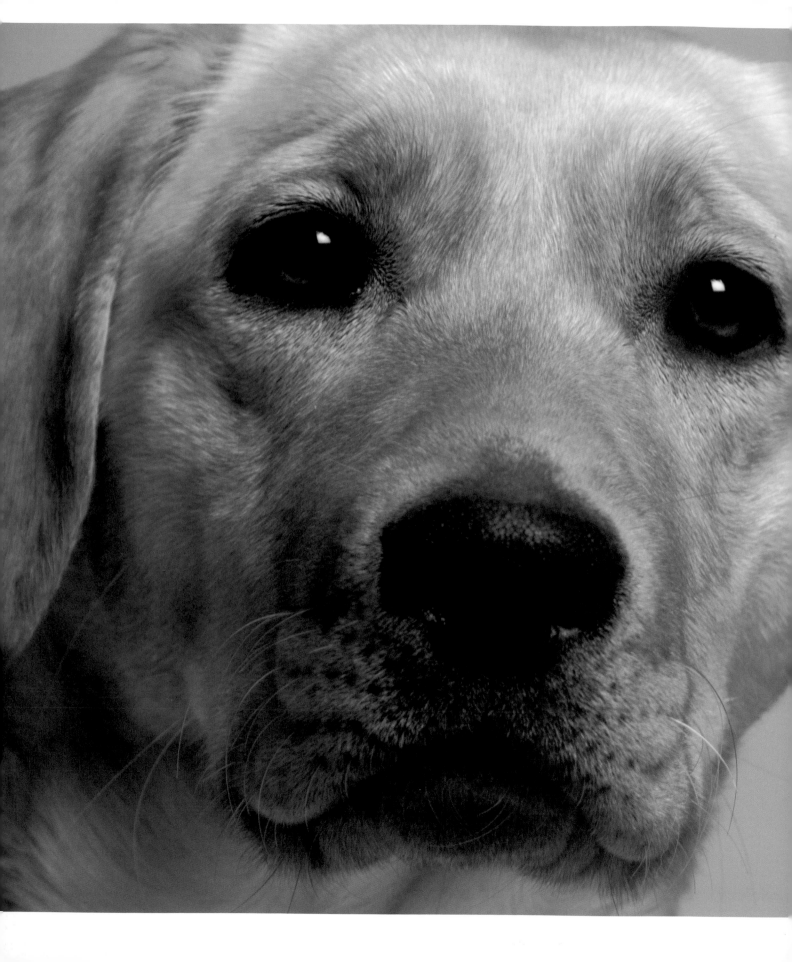

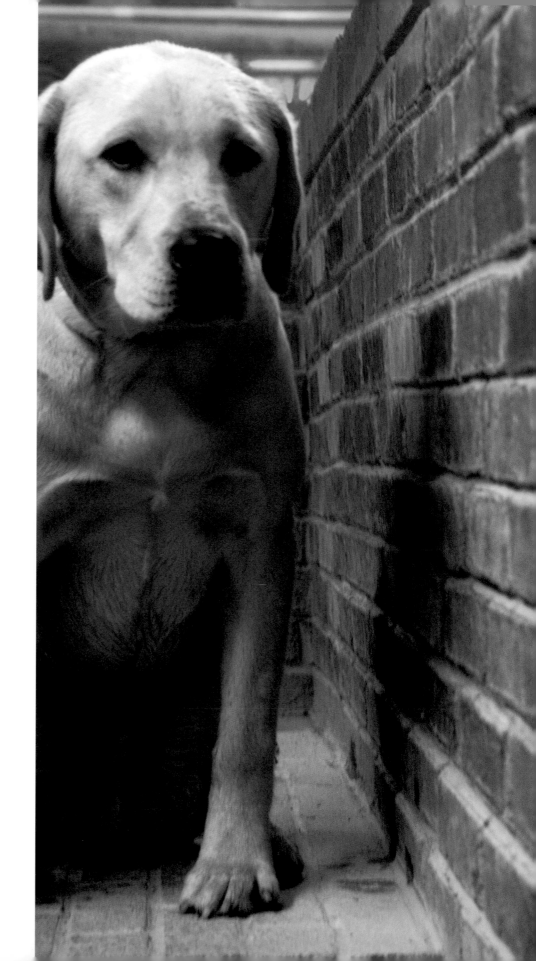

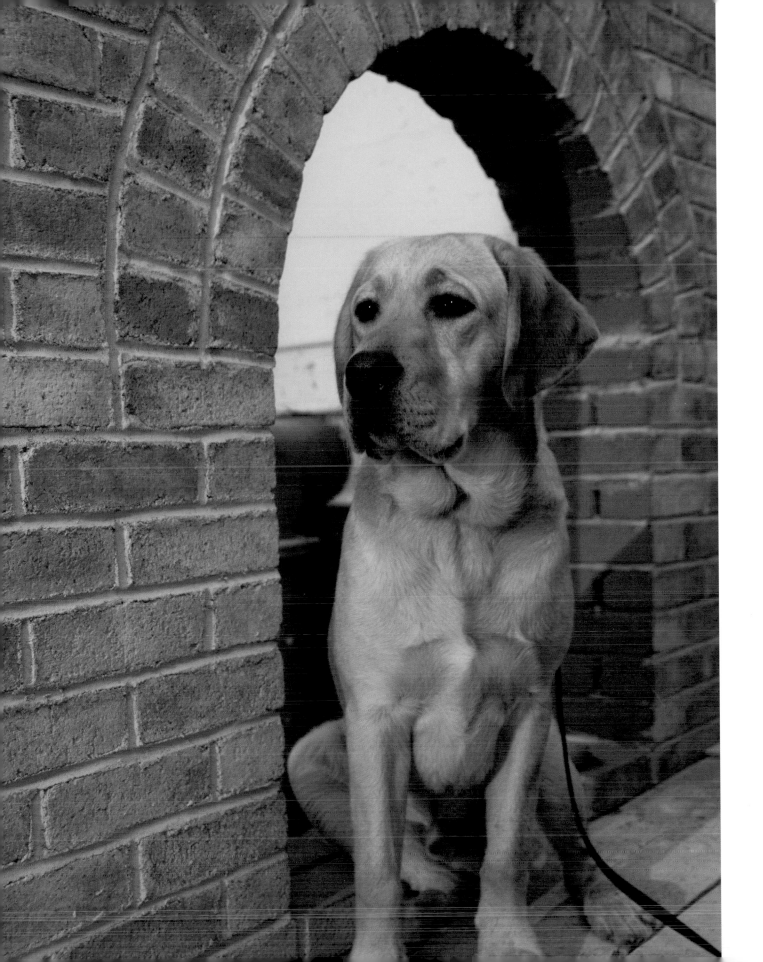

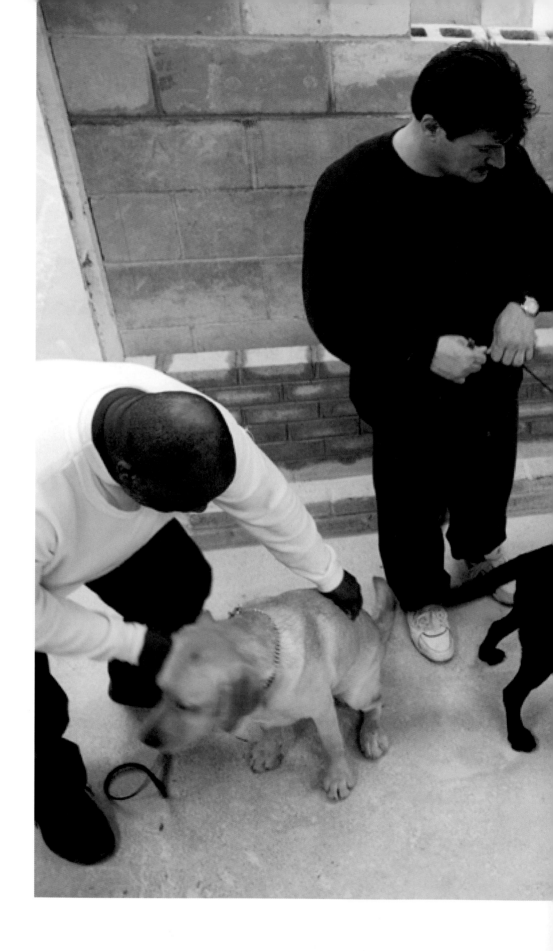

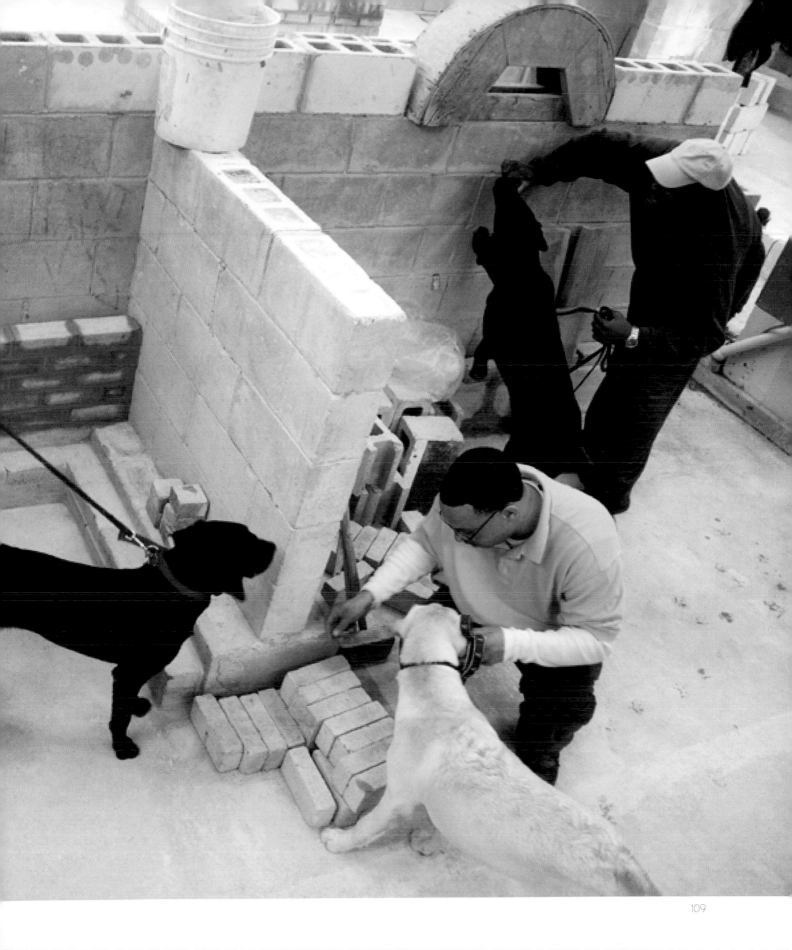

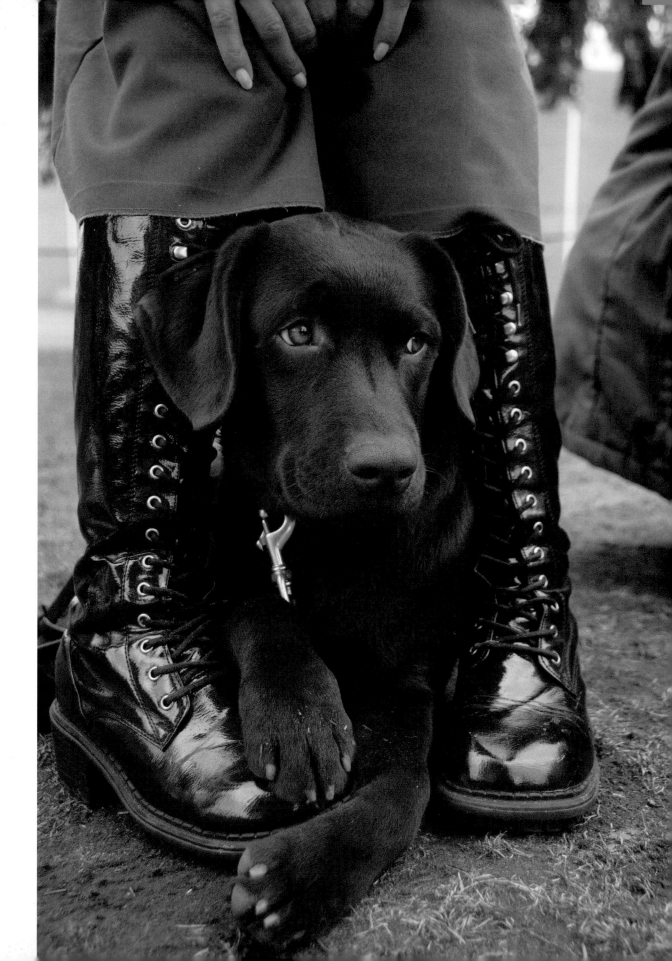

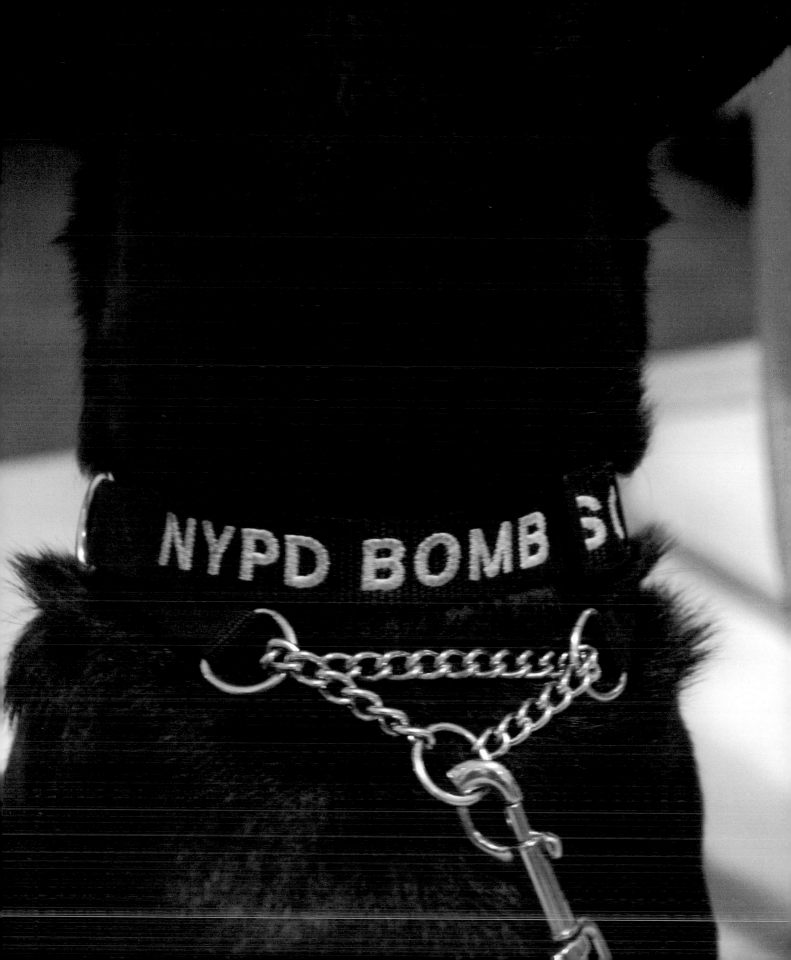

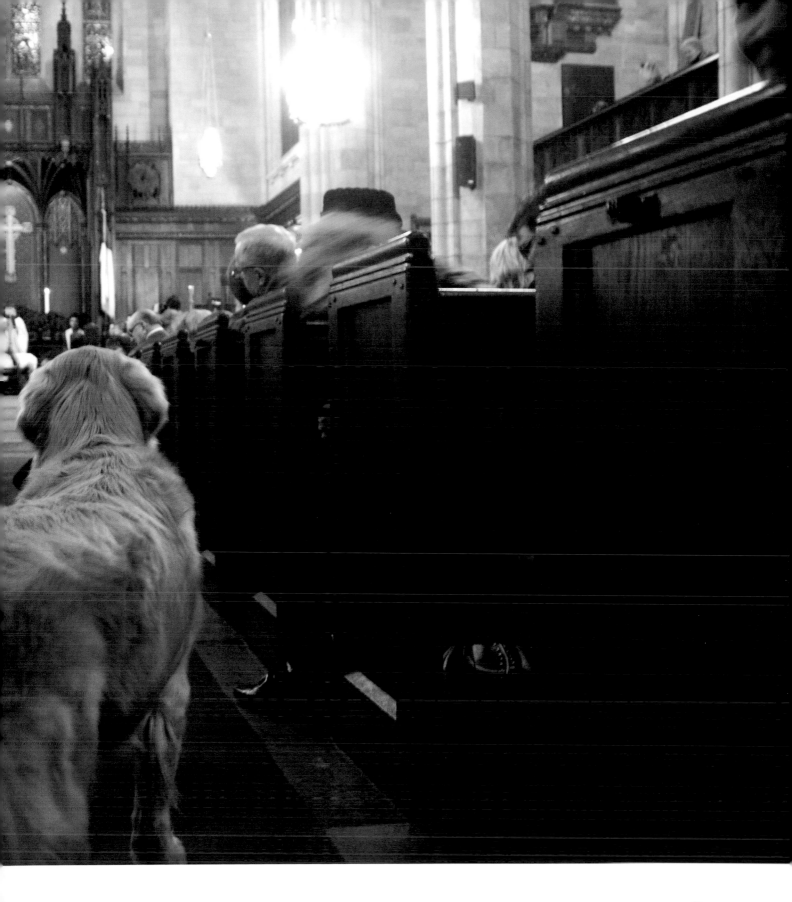

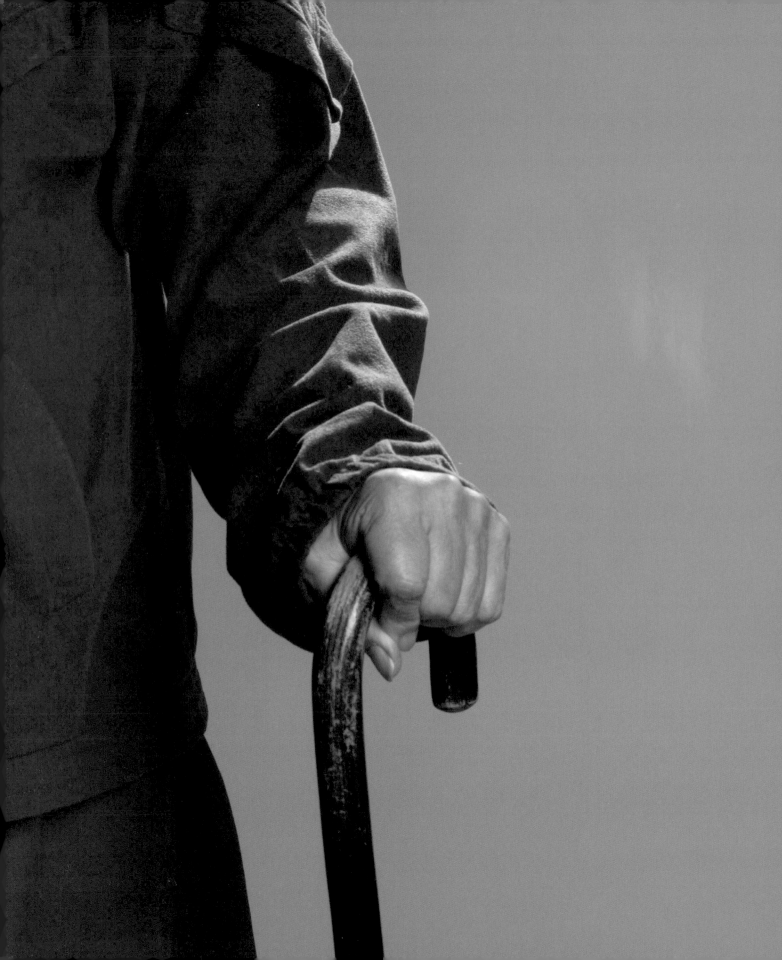

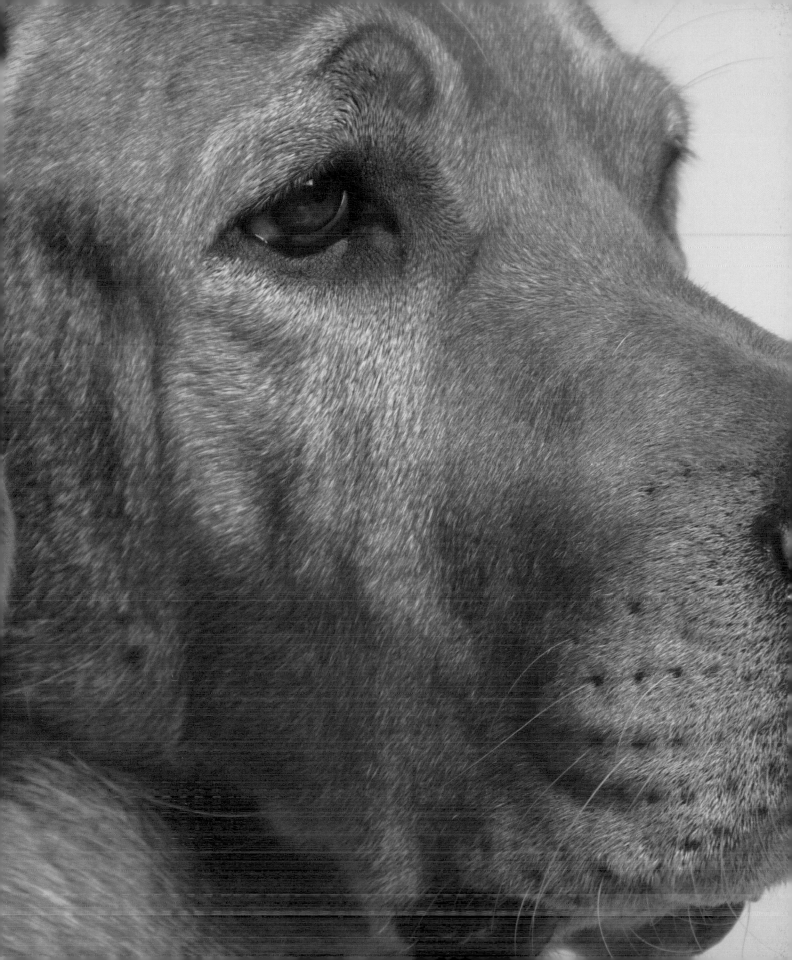

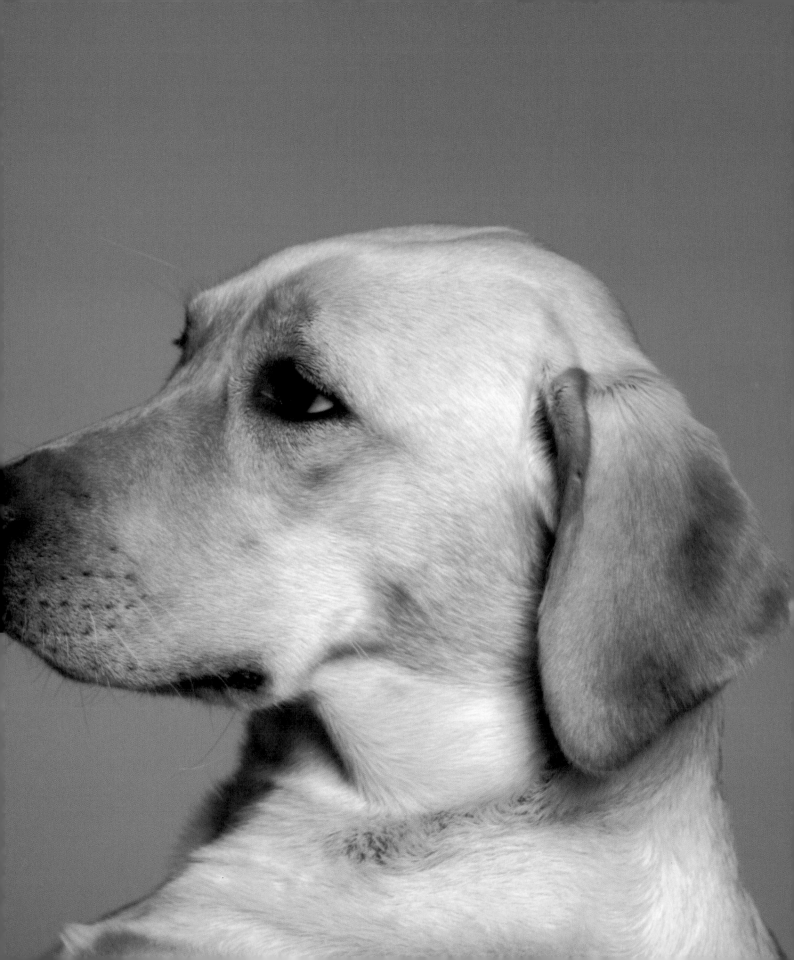

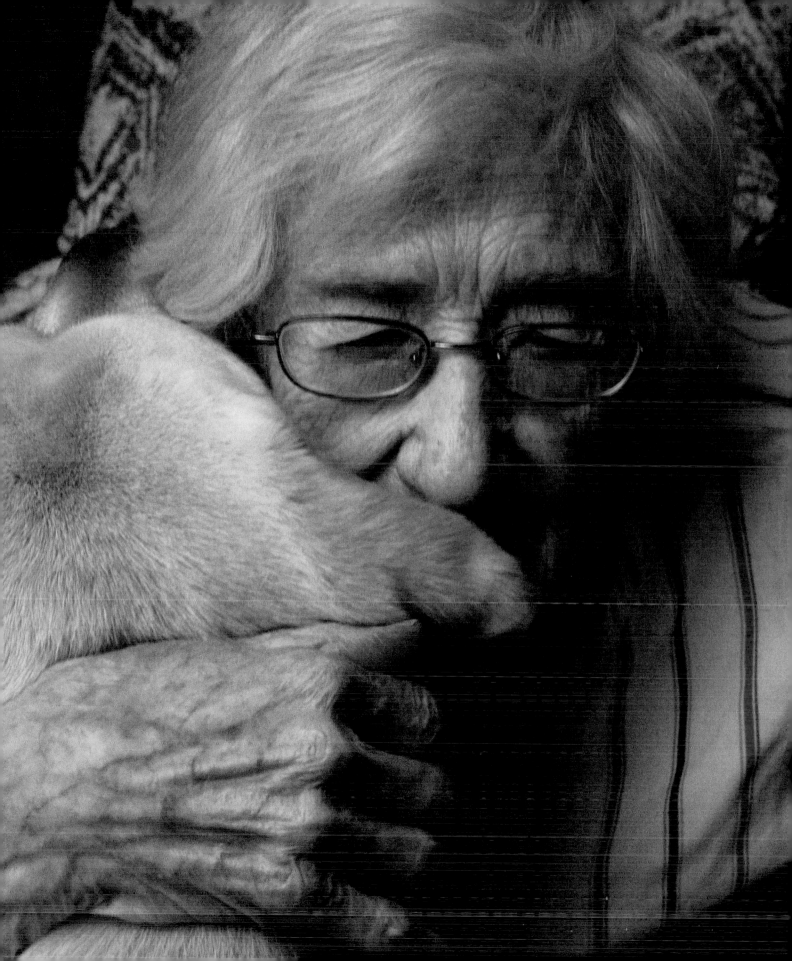

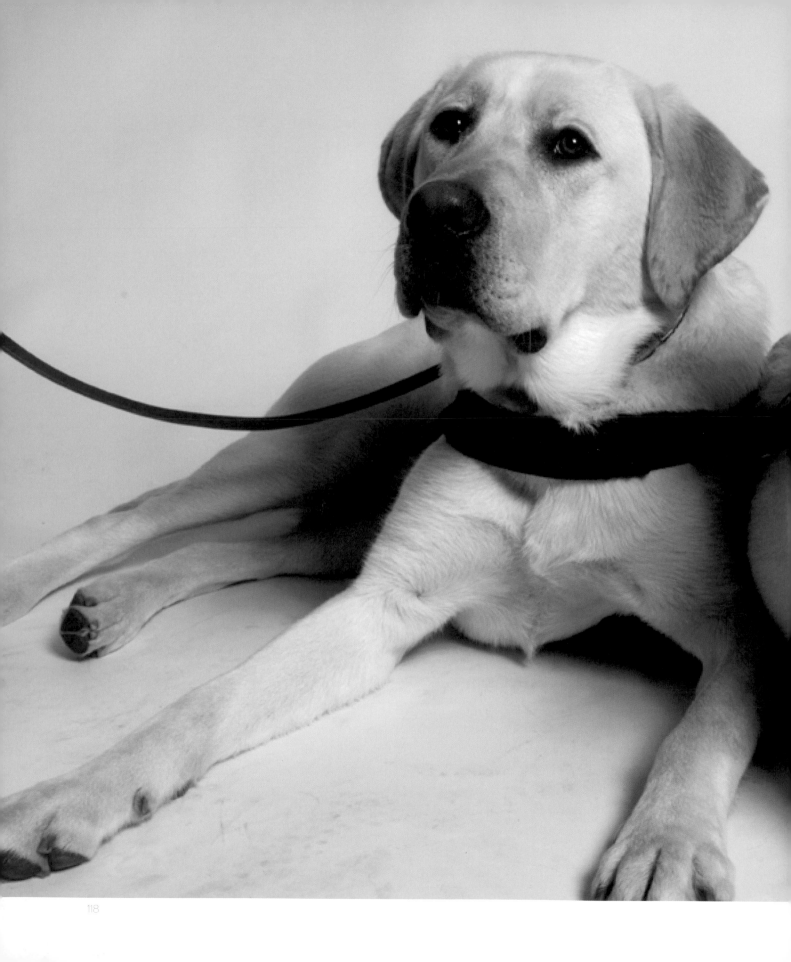

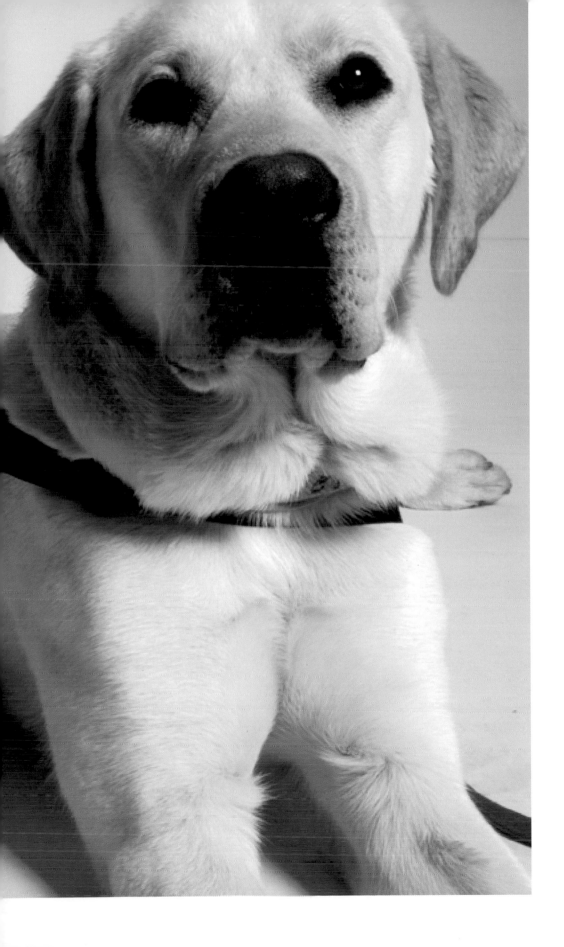

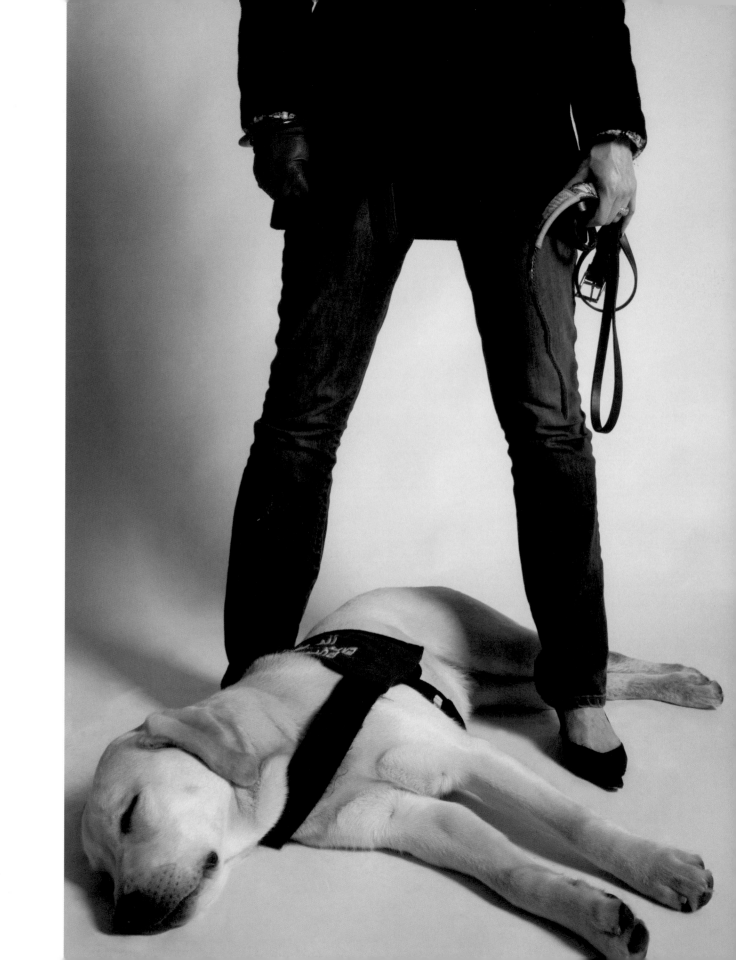

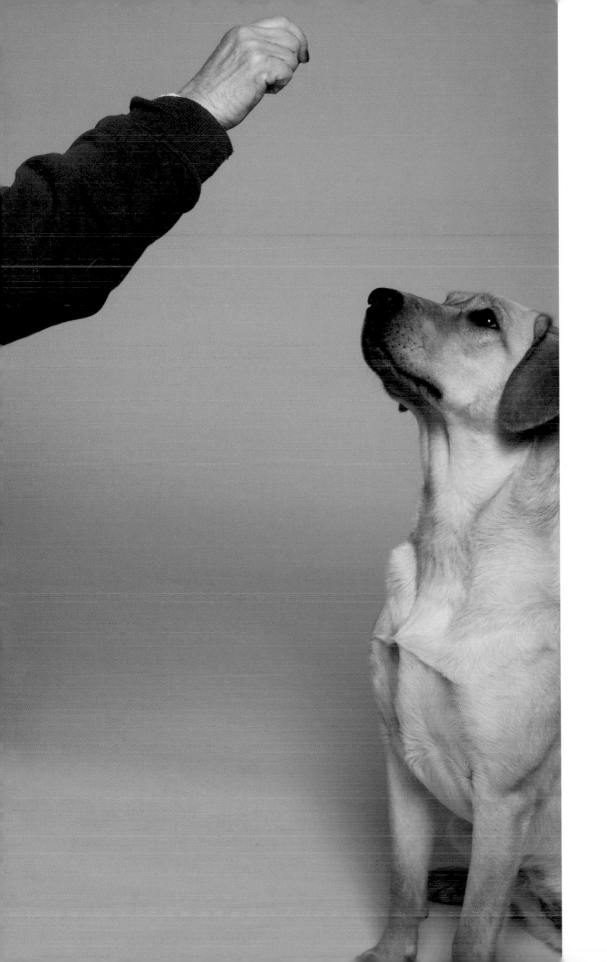

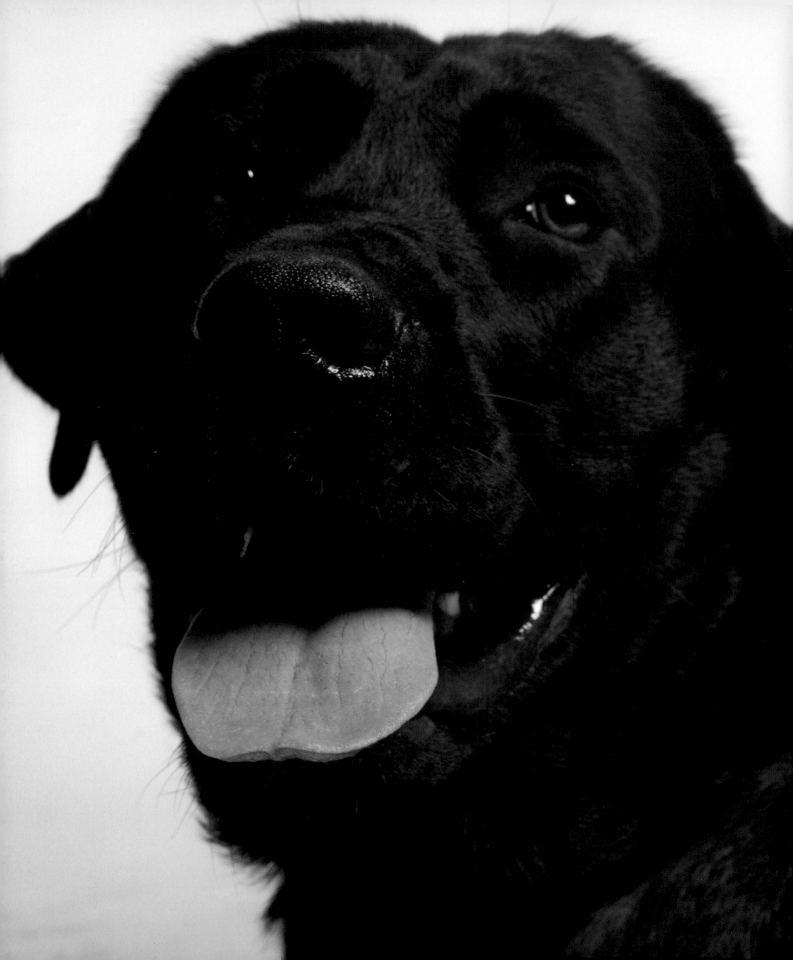

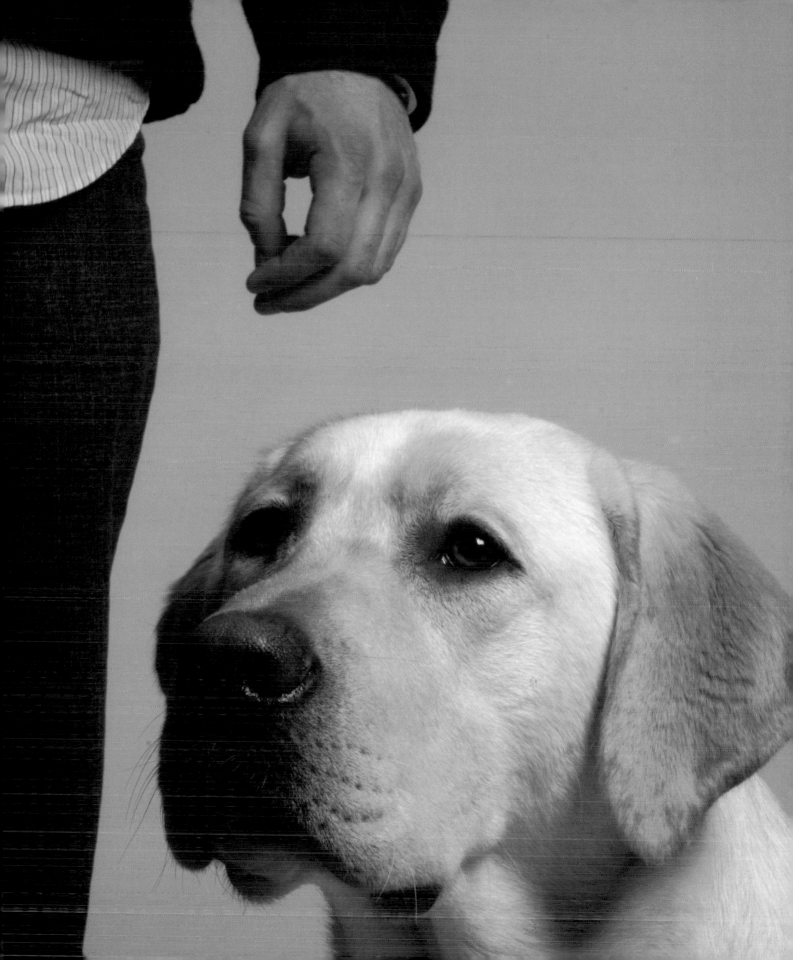

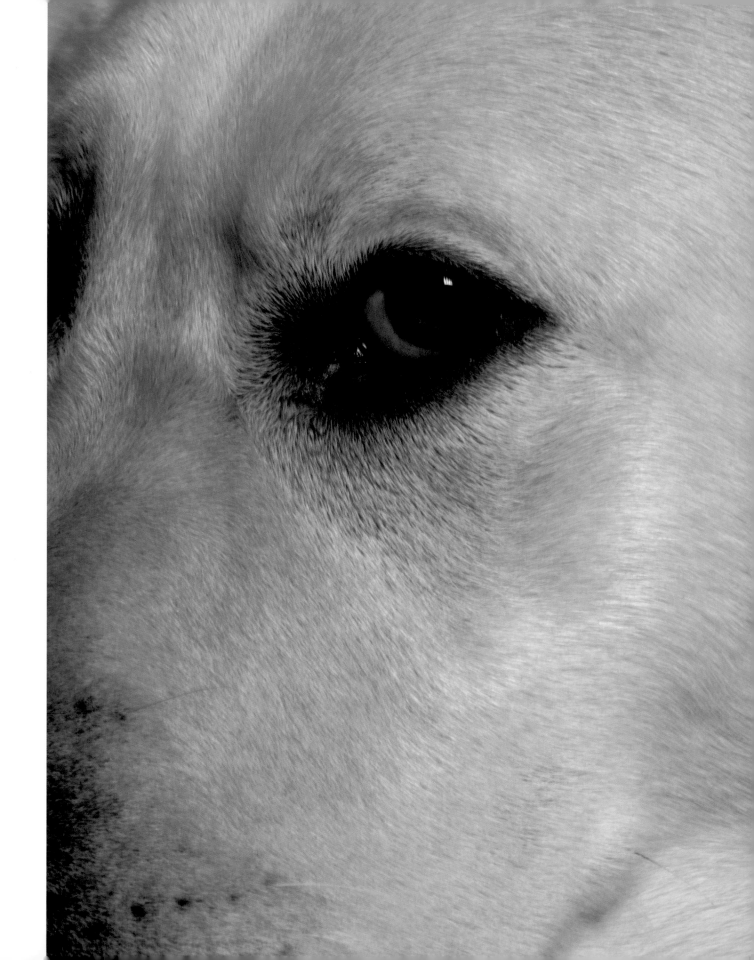

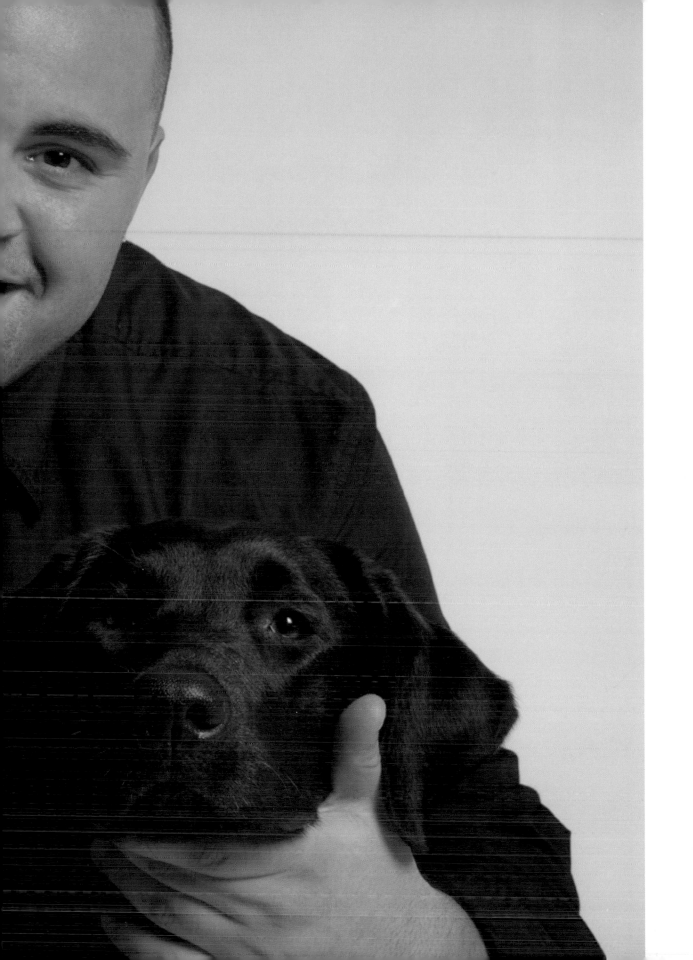

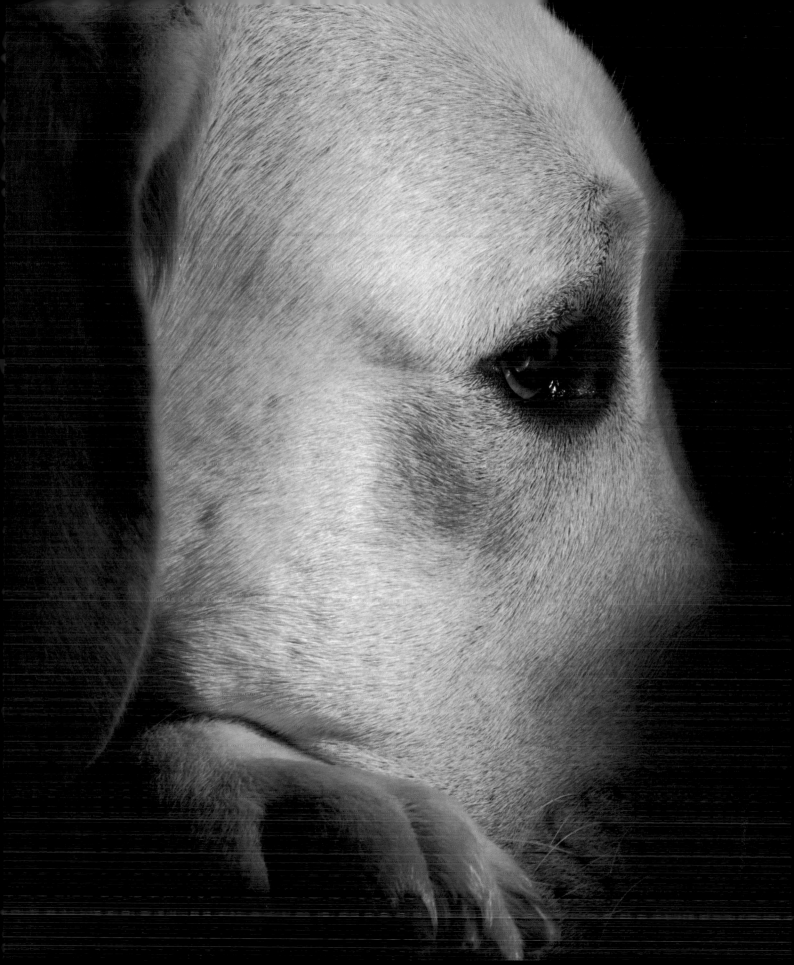

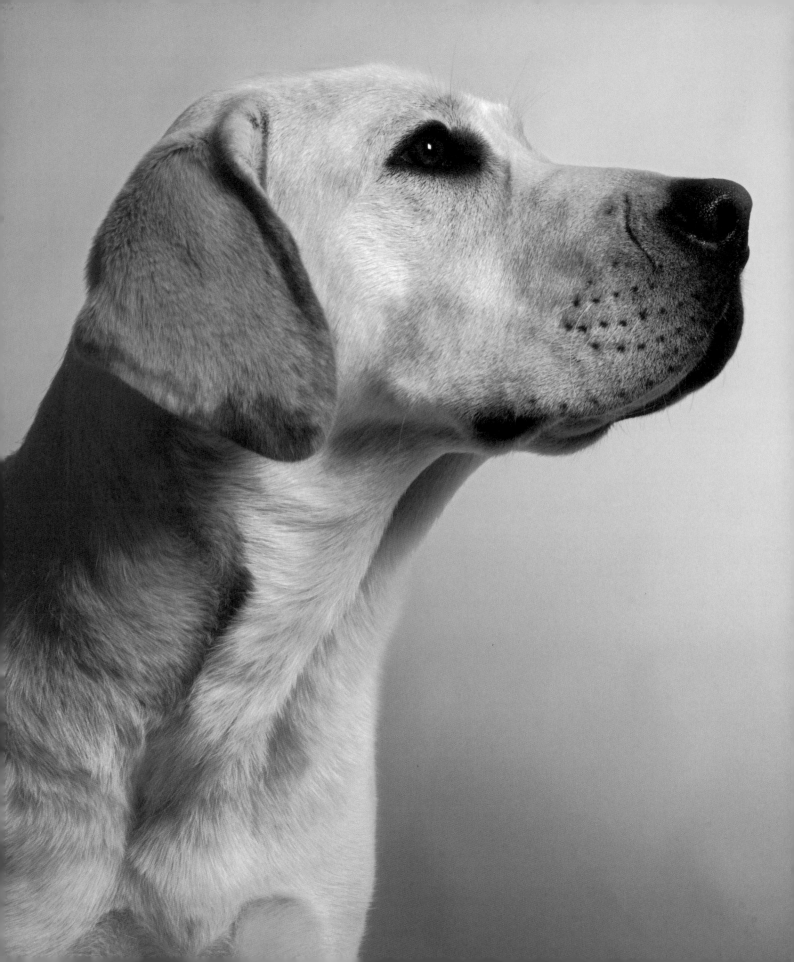

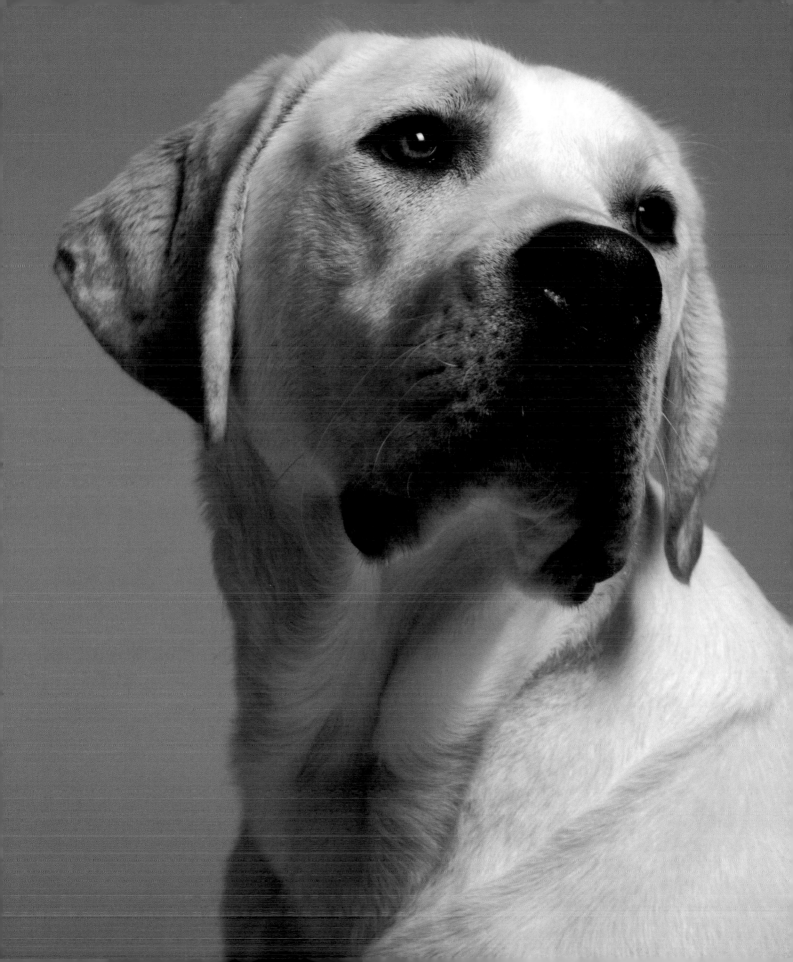

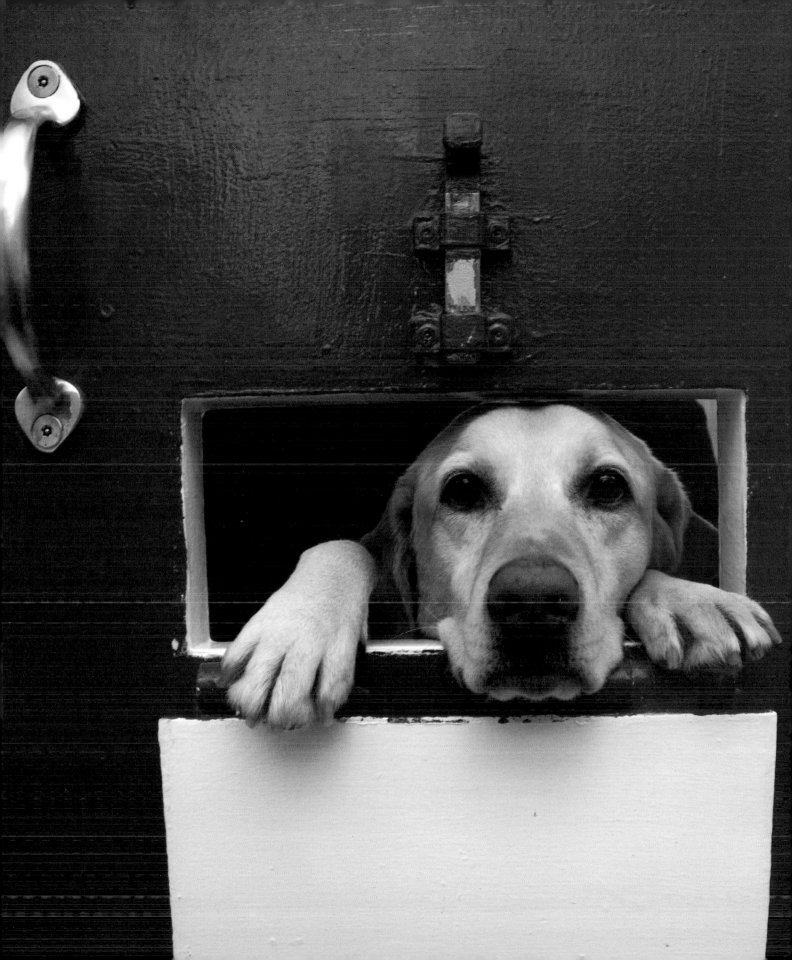

WHERE OUR DOGS WORK

States and Countries in which PBB dogs work:

STATES:

Alabama
Alaska
Arizona
California
Colorado
Connecticut
Idaho
Maine
Maryland
Massachusetts
New Hampshire
New Jersey
New York
North Carolina
Ohio
Oregon
Pennsylvania
South Carolina
Tennessee
Texas
Virginia
Washington
Washington D.C.
Wyoming

COUNTRIES:

Australia
Bahrain
Colombia
Cyprus
Egypt
Indonesia
Italy
Jordan
Malaysia
Mexico
Oman
Qatar
South Africa
Thailand
United States

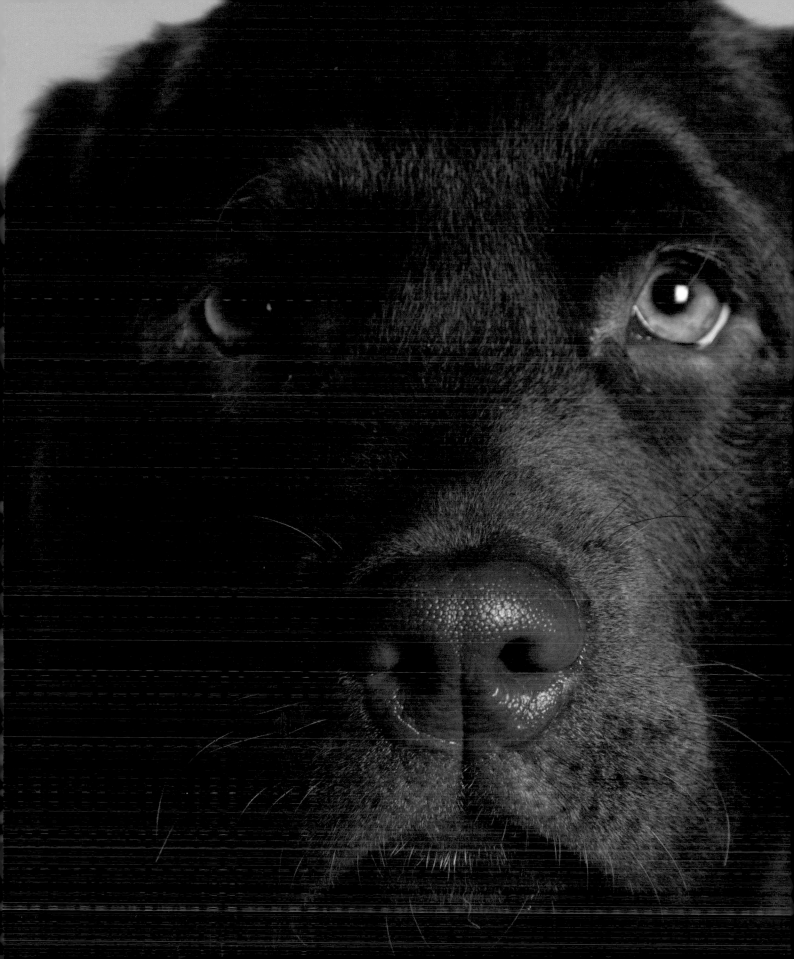

The following comments have been collected by Gloria Gilbert Stoga:

Deputy Superintendent of Programs, Bedford Hills Correctional Facility:

"I love the program. I think one of the things about it is many of the women have not seen a dog for years, so just seeing the dogs and the interactions has the effect of humanizing this environment. You can see the changes with individual inmates. It has that similar effect on the whole campus and the whole facility."

Education Supervisor, Fishkill Correctional Facility:

"When they first told me about the program, I thought, 'This is crazy. Why would we bring this sort of program in for criminals?' But now, I think it's been a Godsend for this facility. The love and attachment the guys have shown for and with the dogs is something I really didn't expect and I don't think a lot of other people expected it, either."

Susan, Bedford Hills Correctional Facility:

"The puppies don't care who you are. They don't care what you look like or what you did, as long as you're good to them."

Roz, Federal Correctional Institute, Danbury:

"You build confidence in your dog and you build confidence in yourself. I am not the person I was. This program has changed me and has changed my life."

Edwin, Fishkill Correctional Facility:

"I am noticing that feelings and emotions which I had closed off for so many years are coming to the surface again. This program is allowing me to regain my humanity."

John, Mid-Orange Correctional Facility:

"The program brings caring back and once you get caring back, you can never let it go again."

Victor, Wallkill Correctional Facility:

"Working with Rosie has made me feel like a real person. Before this program, I spent 13 years feeling like a criminal."

Kim, Edna Mahan Correctional Facility:

"I'm sure the biggest concern is why bad people would want to do a charitable, good thing? There has to be a motive. You are right, there is a motive. We want to be good people doing good things for other people."

Ronald, Otisville Correctional Facility:

"Your macho persona is a goner with these dogs. I've seen 6'2", 250 lb. guys rolling around on the floor and talking in a high voice to their dogs. We all do it, even in the yard with 200 other inmates and guards walking by. We don't care what anybody thinks. It's all about what is good for the dogs. We owe them. They did what nothing or nobody else could—they took away our selfishness."

Margaret, Edna Mahan Correctional Facility:

"...6:30 a.m, it is off to the windy tundra. Out like the wind running my puppy in the yard, rain, sun, snow, heat or cold, I am there. It is what my puppy needs, it makes him happy and healthy, and that brings me joy."

Roberta, Bedford Hills Correctional Facility:
"Many of us in prison have learned from our mistakes and we want nothing more than to be able to add to society the way we once subtracted from it; we do that through our dogs. We don't get paid, nor are we forced to join the Puppies Behind Bars program. We volunteer because we want to do something positive with our time; we want to give back to society."

Michael, Mid-Orange Correctional Facility:
"Being in the program, I saw my peers interact with the puppies like a father would interact with his children. I saw something special taking place before my eyes. I saw guys getting up in the middle of the night to take their puppies out to "get busy." No matter how cold it was outside, I saw guys training with their pups everyday and giving body massages, clipping nails, and grooming the pups. These are tough guys treating these puppies like babies."

Jason, Otisville Correctional Facility:
"For the first time in my 17 years in prison, my day no longer revolves around me. Now when I get up in the morning, the first thing I do is take Daisy out to "get busy." Then I feed her and give her some exercise. Only then can I shower and start my day. It's no longer all about me, me, me."

Sam, Mid-Orange Correctional Facility:
"My mother has Alzheimer's and there's a good chance she will not recognize me when I come home later this year. Yet even though she sometimes forgets my father's face and my name, she somehow always remembers my puppy, Ford, and always asks about him. For me, this means that my mother's last memory of me, rather than my crime, was our love for Ford, and the pride and joy that my participation in PBB brought her."

Philip, Mid-Orange Correctional Facility:
"There are over 700 people in this prison and just 20 of us (puppy raisers). Most inmates do nothing, but we give more than the majority. We're not average inmates."

Jose, Wallkill Correctional Facility:
"I've done something I can't change, but raising these dogs, either to help in the War on Terror or to help a disabled person, provides the opportunity for a part of me to reach out beyond these walls to touch people's lives in a meaningful way."

Billy, Otisville Correctional Facility:
"When I first came to the program I had an image, a cold disposition, that I felt I had to uphold. But PBB taught me not to be afraid to express what I feel. I used to keep my feelings tight, like I had a wall up. I wasn't used to being friendly. But being around the puppies changed all that. My dream is to get out and escort my mother to church every Sunday and for her to be proud of who I am now. I want her to hold her head high when I take her to church."

Jake, former inmate Mid-Orange Correctional Facility, currently administrative assistant, Puppies Behind Bars:
"Puppies Behind Bars played a huge role in changing the direction of my life. Having a puppy to take care of while incarcerated taught me to make decisions with more than just myself in mind. I learned to sacrifice my own wants and needs for the betterment of someone, or something, dear to me. After close to 6 years of being a member of Puppies Behind Bars, my new pattern of decision-making became a permanent part of who I am. I returned to society after 11 years, stripped of my selfishness. My old life, literally, went to the dogs."

Rafael, former inmate Wallkill Correctional Facility, currently administrative assistant, Puppies Behind Bars:
"Puppies Behind Bars was by far the most therapeutic program that I participated in throughout the time that I was incarcerated. The instructors were tough on me because they believed in me and refused to accept anything less than my best for the puppies. Other inmates that I had never said a word to now became my partners in caring for the puppies, and the puppies became my children . . . refusing to accept anything less than 3 meals, 3 massages, 2 hours of recreation, unconditional love, attention, and patience every single day. This taught me that it is a great, selfless feeling to be second to myself.

PBB employed and trained me to work in the office at a time in my life when I was most vulnerable to the pressures around me. Very easily, I could have become a sad statistic of men that return to prison because the pressures of being a responsible citizen overwhelm them. But PBB taught me how to become a productive member of the team and a responsible man in general."

Gussie, 99-year-old volunteer in our Paws & Reflect program:
"We are both imprisoned—for different reasons, yes—but unable to go as we please nonetheless. These special puppies make us laugh, make us feel loved, and help us feel human."

Gordon, 90-year-old volunteer in our Paws & Reflect program:
"Paws & Reflect gives me an interest that I wouldn't have otherwise and for a man this is very important. The wives are always doing things—chatting, belonging to an organization—but the men are inclined to sit back and wither away. This gives me something to get up and look forward to on Saturday. Not just on Saturday, but the whole week!"

Roy, 84-year-old volunteer in our Paws & Reflect program:
"Paws & Reflect gets me out of bed on days I wouldn't otherwise, it brings out a spark in me when I didn't think I had one left, and it has offered me a genuine friendship with Jamie when I didn't believe meeting new friends was possible."

PBB Instructors' Anecdotes:

"One of the first women I interviewed to become a puppy raiser was obviously quite tough, and I began to wonder if I could work with someone who scared me. Then I remembered that I was in a maximum-security prison, so "scary" might come with the territory. I ended up accepting her in the program and she was one of the first two inmates to qualify for a puppy. Several weeks later, one of the other inmates pulled me aside and said, 'You should have seen RJ last night, crying and crying because her puppy was sick. I've got to tell you that RJ used to be so tough, that all of us inmates were scared of her. And now she's crying and asking for help for her puppy.'"

"Beverly, a mother of three, was clearly not as fast a learner as the other women in the class. One day she handed me a letter in which she wrote that she knew she was not very smart, but thanked me for giving her a chance by raising Duke. She promised she would never let me down. And she didn't: Duke is today an Explosive Detection Canine working in Malaysia."

"What I did not know at the time was that for the first years of her sentence, Beverly's children had not visited her because they were embarrassed to be with her in the visiting room of a prison. But once Beverly began to raise Duke, her children began to see her not as 'our mother who is in prison,' but as 'our mother who is raising a dog to help keep the world safe.'"

"The first PBB puppies went into the Bedford Hills Correctional Facility the day before Thanksgiving, 1997. That Saturday evening the phone rang at 10:00 p.m. and a deep male voice asked to speak with Mrs. Stoga. My heart dropped: That voice, at that hour, made me fear that something bad had happened. He identified himself as a corrections officer and told me that he was worried about one of the pups; he had felt the dog's nose, which seemed too warm, and he had immediately called me. After a few questions, it became clear that the pup was just tired and a bit overwhelmed and would almost certainly revive with some rest. But the image of this particular officer, who is built like a linebacker, on his hands and knees feeling a 5 pound Labrador puppy's nose told me, without a doubt, that all our puppies would be safe."

"Of course, one of the biggest differences between working with men and women is that the male inmates pride themselves on not showing emotion—at least at first. Sixteen months after Richard got his little yellow puppy Rosetta, she was ready to leave for guide dog school. Much to my surprise, as Richard handed me her lead for the last time, the tears streamed down his face. Even more surprising, we were standing next to a corrections officer in a walkway filled with other inmates, who would certainly see his tears. Puppies may not move mountains, but they can move men!"

"John, who was serving a 25 to life sentence, was the first to sign up when we started at Mid-Orange. He explained that he wanted some chaos in his life. 'Everything in prison is regulated. With a puppy, new, unexpected things will happen every day, just like they do out in society.'"

"Two weeks before Rudy was to leave Mid-Orange, the full impact hit Jack, his raiser. We noticed them spending more and more time in the rec yard, away from everyone else—playing, retrieving balls, and just being together. He said, 'I know he will be a success whatever he does, and I know that part of me is going out there with him. It's not just an idle dream that I have finally done something right. When I look at this dog, I know it.'"

"I discovered one unforeseen consequence of all the effort and all the hours that the inmates pour into their dogs. One day an obviously proud puppy raiser at the Bedford Hills prison told me an officer had begun asking her advice on how to raise his new puppy. Suddenly, the inmate was the teacher!"

"Wilberto, who is very shy, spent his entire "bid" trying to blend in. Suddenly, once he got his puppy, he started being noticed. Officers who had not spoken to him in 17 years started saying hello and asking about the dog. 'It made me come out of my shell and I learned how to relate to people.'"

"Cindy inherited her dog, Jenny, when the dog was 8-months old and her raiser quit the program, leaving a dog that needed a lot of extra work. The other puppy raisers did not think Cindy was qualified and, at first, shunned her. More than once Cindy asked me, in tears, if she should leave the program. But she stayed and week by week, Jenny began to show progress. First grudgingly and then openly, the other raisers accepted Cindy, not for who she was but for what she was accomplishing. Today Jenny is a working guide dog and Cindy has gone on, not only to raise several other dogs for us, but to become a mentor to other women entering the program."

"When Detective Bill Lutz, formerly of the NYPD Bomb Squad, first visited Mid-Orange with his PBB-raised explosive detection canine Gus, he was a bit skeptical. 'I've spent my life locking up guys like these. I wasn't sure what to expect. But the way they worked with their dogs, their focus on the job at hand, and the kinds of questions they asked me showed a degree of dedication and commitment that easily matched what I had seen with dog trainers on the outside. This is about the dogs, not about the men's history.'"

Virginia, New York City volunteer:
"I can say what I do as a volunteer but honestly, the puppies and volunteering have done more for me. I hope the puppies can now teach my children what they have taught me which is to think outside of one's own life and to help one another."

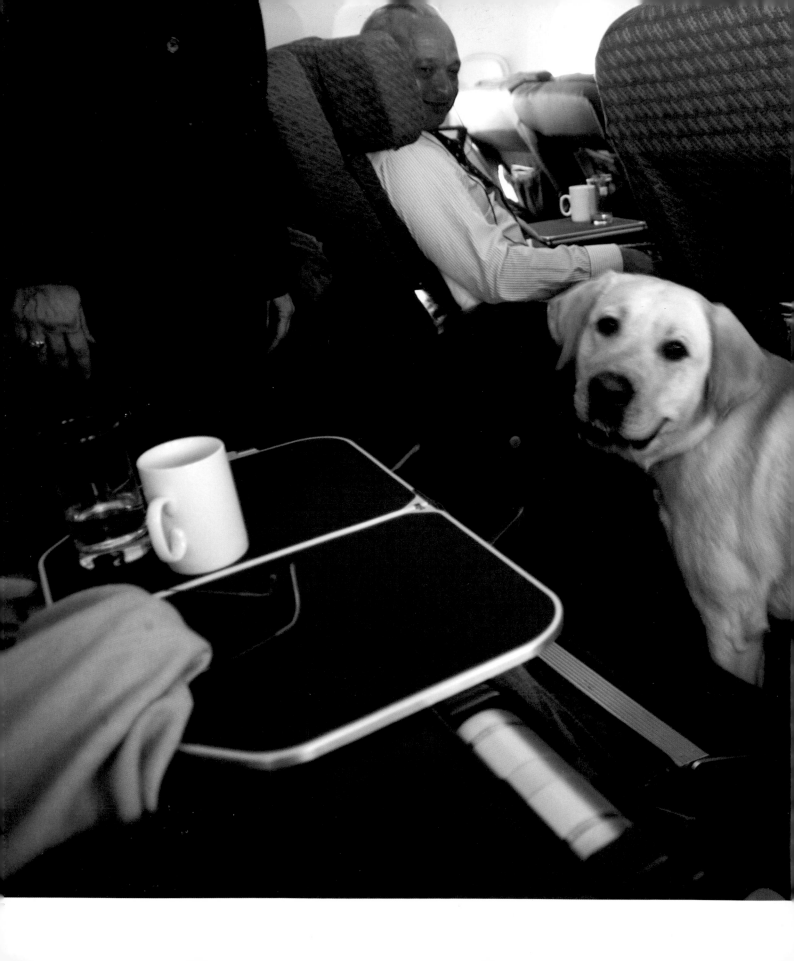